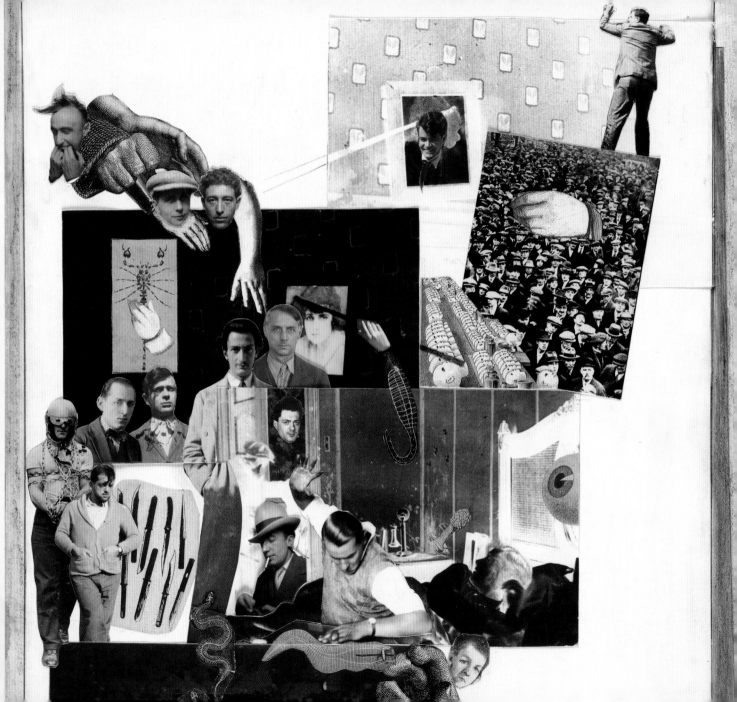

SURREAL PEOPLE

Surrealism and Collaboration

Alexander Klar

V&A Publications

First published by V&A Publications, 2007
V&A Publications
Victoria and Albert Museum
South Kensington
London SW7 2RL

Distributed in North America by Harry N. Abrams, Inc., New York

© The Board of Trustees of the Victoria and Albert Museum, 2007

The moral right of the author has been asserted.

ISBN 978 1 85177 503 3
Library of Congress Control Number 2006936573

10 9 8 7 6 5 4 3 2 1
2011 2010 2009 2008 2007

A catalogue record for this book is available from the British Library.

Every effort has been made to seek permission to reproduce those images whose copyright does not reside with the V&A, and we are grateful to the individuals and institutions who have assisted in this task. Any omissions are entirely unintentional, and the details should be addressed to V&A Publications.

Designed by johnson banks

New V&A photography by Christine Smith, V&A Photographic Studio

Jacket design by johnson banks

Frontispiece: Max Ernst, *Loplop introduit des membres du groupe surréaliste* (Loplop Introduces Members of the Surrealist Group), detail. Collage with photographs, pencil and frottage. 1931. Museum of Modern Art, New York

Printed in China

V&A Publications
Victoria and Albert Museum
South Kensington
London SW7 2RL
www.vam.ac.uk

CONTENTS

FORTUITOUS ENCOUNTERS

No other movement in art has championed intellectual exchange and artistic collaboration to such an extent as Surrealism. Being a group of close friends, the Surrealists shared their lives, their thoughts, their studios and their work. Together they wrote manifestos and books, edited magazines, staged protests and organized and designed exhibitions. Interviewed by James Johnson Sweeney in 1946, Max Ernst summed up what can be read as a Surrealist credo: 'Art is not produced by one artist, but by several. It is to a great degree a product of their exchange of ideas one with another.'[1] Max Ernst's statement, made in New York in 1946, reflected the sentiments of many European Surrealists who had sought refuge in America during the war. Having narrowly escaped the fascist occupation of France, they now regretted the loss of a culture of lively discourse and exchange fostered by the cafés and meeting places of Paris.

Encounters, friendship, and the ensuing mutual collaborations were an integral part of the ethics and aesthetics of Surrealism. Its motto and guiding principle was the poet Isidore Lucien Ducasse's extensively quoted phrase: 'Beautiful as the fortuitous encounter of a sewing machine and an umbrella on a dissection table.' Ducasse, who in 1868 had written his seminal work *Les Chants de Maldoror* (The Songs of Maldoror), under the pseudonym Comte de Lautréamont, was hailed as one of the prophets of Surrealism for his ability to evoke images of absurd beauty by connecting what logically and semantically did not seem to be related. Sigmund Freud's explorations of the subconscious were just as eagerly absorbed by the group of young writers

Man Ray, *Enquête*,
published in *Minotaure*, no. 3–4,
1933. NAL: SD.95.0018

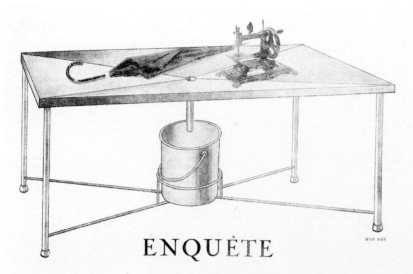

ENQUÊTE

MAN RAY

«... Beau comme la rencontre fortuite sur une
table de dissection d'une machine à coudre et
d'un parapluie ! » (Comte de Lautréamont :
Les Chants de Maldoror).

Pouvez-vous dire quelle a été la rencontre capitale de votre vie ?

*Jusqu'à quel point cette rencontre vous a-t-elle donné, vous
donne-t-elle l'impression du fortuit ? du nécessaire ?*

André Breton, Paul Eluard.

Si l'accueil fait à cette enquête (cent quarante réponses pour environ trois cents questionnaires distribués) peut passer quantitativement pour très satisfaisant, il serait abusif de prétendre que tous ses objectifs ont été atteints et qu'en particulier le concept de rencontre en sort brillamment élucidé. Toutefois, la nature même des appréciations qui nous sont parvenues, l'insuffisance manifeste du plus grand nombre d'entre elles et le caractère plus ou moins réticent ou oscillatoire d'une bonne partie de celles qui ne sont pas purement et simplement « à côté » nous confirment dans le sentiment qu'il pouvait y avoir, en un tel point, prétexte à un sondage intéressant de la pensée contemporaine. Il n'est pas jusqu'au malaise résultant d'une lecture continue et quelque peu attentive des pages qui vont suivre — d'où se détachent pourtant plusieurs témoignages très valables et que parcourent de brefs traits de lumière — que nous ne tenions pour révélateur d'une inquiétude dont le sens est beaucoup plus large qu'il n'a été donné de l'admettre à la moyenne de nos correspondants. Cette inquiétude traduit, en effet, selon

toutes probabilités, le trouble actuel, paroxystique, de la pensée logique amenée à s'expliquer sur le fait que l'ordre, la fin, etc., dans la nature ne se confondant pas objectivement avec ce qu'ils sont dans l'esprit de l'homme, il arrive cependant que la nécessité naturelle tombe d'accord avec la nécessité humaine d'une manière assez extraordinaire et agitante pour que les deux déterminations s'avèrent indiscernables. Le hasard ayant été défini comme « la rencontre d'une causalité externe et d'une finalité interne », il s'agit de savoir si une certaine espèce de « rencontre » — ici la rencontre capitale, c'est-à-dire par définition la rencontre subjectivée à l'extrême — peut être envisagée sous l'angle du hasard sans que cela entraîne immédiatement de pétition de principe. Tel était le plus captivant des pièges tendus à l'intérieur de notre questionnaire. Le moins qu'on puisse dire est qu'il a été rarement évité.

Mais il y avait à peine malice de notre part à compter obtenir de chacun de ceux que nous sollicitons une réponse extrêmement

101

Fortuitous Encounters

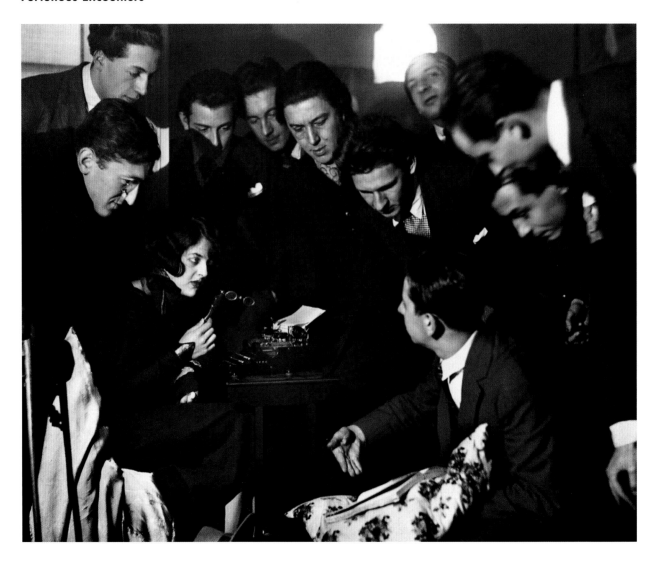

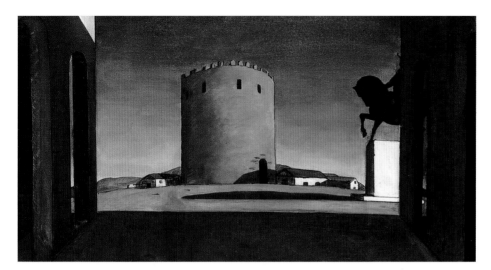

and poets that would frequently gather for dream séances, held at the Bureau des Recherches Surréalistes from 1924 onwards.

Man Ray's snapshot of one of the earliest gatherings of the *Rêve Éveillé* (Awakened Dream) captured the group listening to Robert Desnos' (seated lower right) account of a dream. With the exception of the photographer himself (whose blurred head is visible on the upper right), there was only one artist present, Giorgio de Chirico, whose dreamlike metaphysical paintings were deemed a genuine form of Surrealist imagery.

The fundamental Surrealist expression was thought, as André Breton famously defined: 'SURREALISM, n. Psychic automatism in its pure state, by which one proposes to express – verbally, by means of the written word, or in any other manner – the actual functioning of thought. Dictated by the thought, in the absence of any control exercised by reason, exempt from any aesthetic or moral concern.'[2] Consequently there is no single stylistic language of Surrealism: the modes through which to express thought, feelings and the subconscious were a matter of artistic temperament and formation. What was shared was a wealth of techniques which were developed and discussed together, and an imagery that was strongly informed by personal iconography. This book sets out to examine the Surrealists' various modes of collaboration, from personal friendships, sexual relationships, joint exhibitions, to more commercial activities such as collecting, curating and advising. It aims to explore the impact of the various 'fortuitous encounters' upon the genesis of some of the most celebrated objects of

Fortuitous Encounters

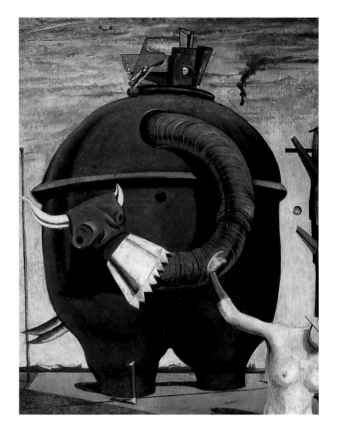

Surrealism, and to present the network of exchanges that helped create these objects.

Surrealism emerged during a decade of intellectual and social turmoil. By the end of the First World War, the previous century's deep-seated, almost religious, belief in the rationality of human progress was shattered. The battlefield of Europe now became the centre of political, philosophical, literary and artistic experiments of every imaginable kind. Surrealism was to be one of these experiments, initiated by a group of young poets and artists who aimed to restore faith in humanity, by revealing what was beyond the human mind. As they proudly proclaimed: 'Surrealism is based on the belief in the superior reality of certain forms of previously neglected associations, in the omnipotence of dream, in the disinterested play of thought. It tends to ruin once and for all all other psychic mechanisms and to substitute itself for them in solving all the principal problems of life.'[3]

It was the shared perception of this generation that western culture, and particularly the single-minded positivism of the nineteenth century, had led to disaster and a war machinery of hitherto unknown brutality. Against the order that had unleashed such atrocity they favoured creative chaos as the only possible foundation

of a new and better society. The avant-garde of this rebellion had already gathered during the war in Switzerland. In January 1916, Hugo Ball, a young German who had fled his country as a conscientious objector, rented the Café Voltaire at Spiegelgasse No.1 in the heart of the medieval centre of Zürich, as a venue for poetry readings, exhibitions and dance entertainment. He was joined by two Romanians, the poet Tristan Tzara and painter Marcel Janco, and another German, Richard Huelsenbeck. On 5 February 1916, the first soirée of the Cabaret Voltaire was staged. It was to become the founding institution of Dada, a movement – or rather an *anti*-movement – of unexpected consequences. Defining itself as 'anti-art', the creative output of its members knew few boundaries. Protest, absurdity and a strong sense of theatricality were the most important features of the manifestations of these international young intellectuals.

This close-knit group was to become a model for and direct predecessor of Surrealism in its approach towards collective staging of poetry and art. Even though Surrealism would later renounce the nihilistic attitude of Dadaism, the spirit of Dada would shape the first years of the Surrealist movement, not least because many of its followers became Surrealists. Two founding members of Dada, Tristan Tzara and Jean Arp, were participants in Surrealist activities throughout the 1920s; Max Ernst, the founder of the Cologne Dada group, was to be one of the most prolific Surrealists, while André Breton, the future leader of the Surrealists, was among the most active members of Dada in Paris.

Opposite: Max Ernst, *Celebes*. Oil on canvas. 1921. Tate Gallery

Below: René Magritte, '*Je ne vois pas la femme cachée dans la forêt*', from *La Révolution Surréaliste* (Paris, 1929), no.12. NAL: PP.64.6

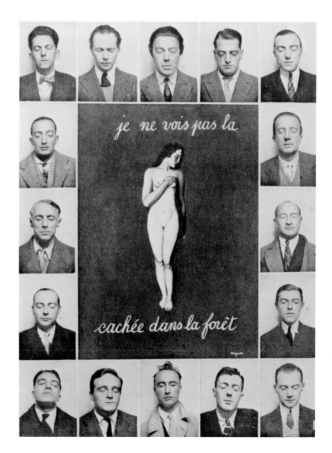

je ne vois pas la

cachée dans la forêt

MARCEL DUCHAMP AND MAN RAY: PRE-SURREALISM

One of the earliest and most long-lasting relationships of Surrealism was that of Marcel Duchamp and Man Ray, two major protagonists of the movement. They met in September 1915 in Ridgefield, New Jersey, an artists' colony where Man Ray had settled to paint, far from the distractions of New York city life. In his autobiography, *Self Portrait*, Man Ray recalled their first meeting:

> One Sunday afternoon two men arrived –
> a young Frenchman, and an American
> somewhat older. The one was Marcel Duchamp,
> the painter whose *Nu Descendant un Escalier*
> (Nude Descending a Staircase) had created
> such a furor at the Armory show in 1913,
> the second a collector of modern art, Walter
> Arensberg. Duchamp spoke no English,

> my French was nonexistent ... I brought out
> a couple of old tennis rackets, and a ball which
> we batted back and forth without any net,
> in front of the house. Having played the game
> on regular courts previously, I called the
> strokes to make conversation: fifteen, thirty,
> forty, love, to which he replied each time with
> the same word: 'yes'. [4]

After Man Ray's return to New York in 1916, he visited Duchamp's studio, where he was drawn to a large glass covered with intricate patterns laid out in fine lead wires: Duchamp's *La Mariée mise à nu par ses célibataires, même* (The Bride Stripped Bare By Her Bachelors, Even). Begun the previous year, Duchamp would not finish the piece until 1923. The work,

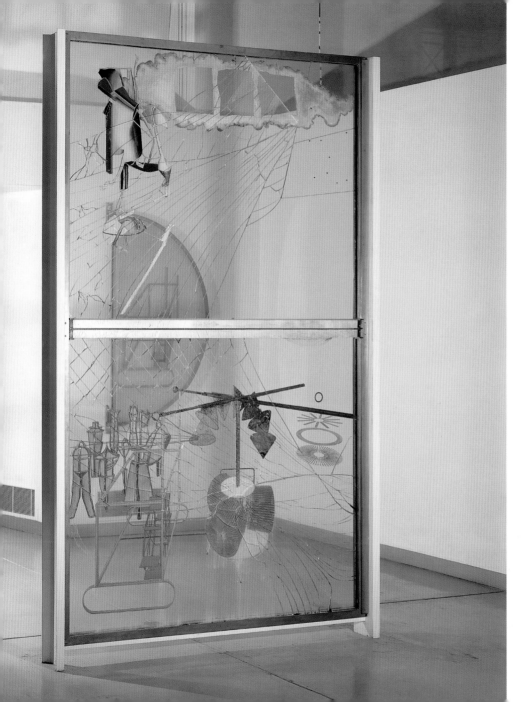

Marcel Duchamp, *La Mariée mise à nu par ses célibataires, même* (The Bride Stripped Bare By Her Bachelors, Even). Oil, lead, dust and varnish on glass. 1915–23. Philadelphia Museum of Art

Marcel Duchamp and Man Ray: Pre-Surrealism

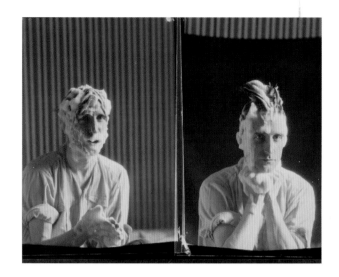

Right: Man Ray, Marcel Duchamp.
Photograph. 1924. Musée national d'art
moderne, Centre Georges Pompidou

Opposite: Man Ray, *Élevage de poussière*
(Dust Breeding), detail. Photograph. 1920.
Man Ray Trust

a playful machinery of desire and sexual dependency, depicts the encounter of a cloud-shaped 'bride' (on the upper panel) with nine 'bachelors' (on the lower glass). The dehumanized appearance of the bride and her bachelors, together with a mechanical apparatus, the 'chocolate grinder', created an air of enigmatic inaccessibility that aroused Man Ray's admiration. He suggested photographing the work and returned to Duchamp's studio in 1920, not simply to record the piece, but to interpret it through his imaginative lens:

> Looking down on the work as I focussed
> the camera, it appeared like some strange
> landscape from a bird's-eye view. There was

dust on the work and bits of tissue and cotton wadding that had been used to clean up the finished parts, adding to the mystery. This, I thought, was indeed the domain of Duchamp. Later he titled the photograph *Élevage de Poussière* (Dust Breeding). [5]

Man Ray's seemingly casual choice of photographic angle, 'adding to the mystery', took Duchamp's work on the elementary theme of life one step further by presenting it as an enigmatic landscape, waiting to be explored. The mutual appropriation of objects as well as the reciprocal naming of artworks was to be the model for future practice within the circle of Surrealists.

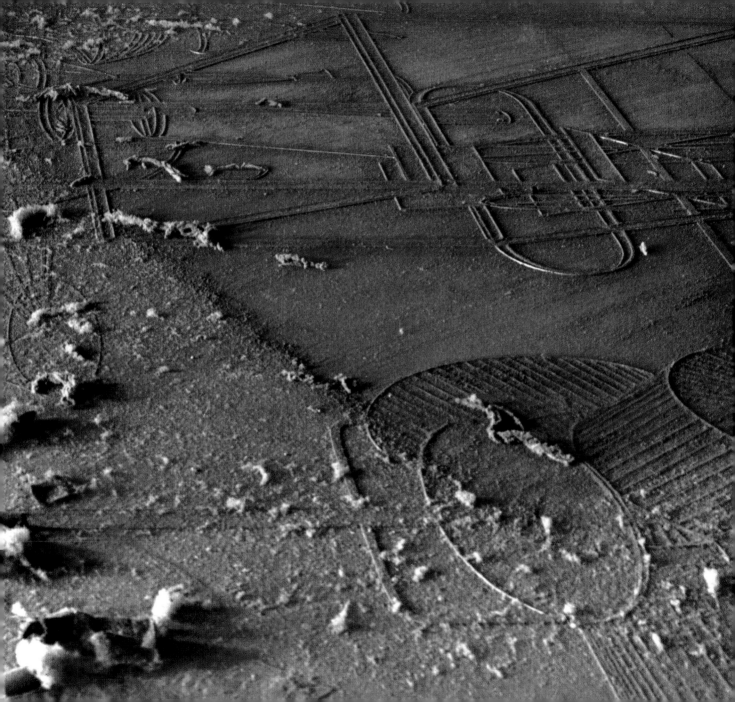

JEAN ARP AND
MAX ERNST: FATAGAGA

Max Ernst and Jean Arp met in spring 1914 in a
gallery in Cologne, and were reunited in October
1920 when Arp returned to live with the Ernst family.
Parallel to their joint efforts to set up a branch of Dada
in Cologne, they worked on their shared project:
FATAGAGA, the *'Fabrication de tableaux garantis
gasométriques'* (Fabrication of Guaranteed Gasometric
Paintings). One of these was *Physiomythologisches
Diluvabild* (Physiomythological Flood Picture), a joint
collage by Arp and Ernst which can be interpreted
as a comment on the agony of the German Republic.
The headless torso of a posing bodybuilder forms a
swastika, the emblem worn by the insurgent troops of
the 'Kapp-Putsch' when trying to overthrow the recently
established Republic. Their comment on such topical
events showed the two Dadaists Arp and Ernst drifting

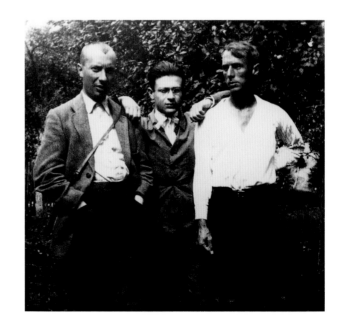

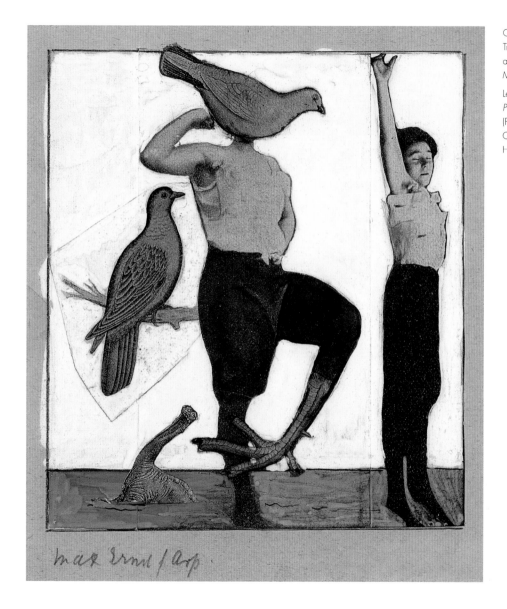

max ernst / arp.

Jean Arp and Max Ernst: FATAGAGA

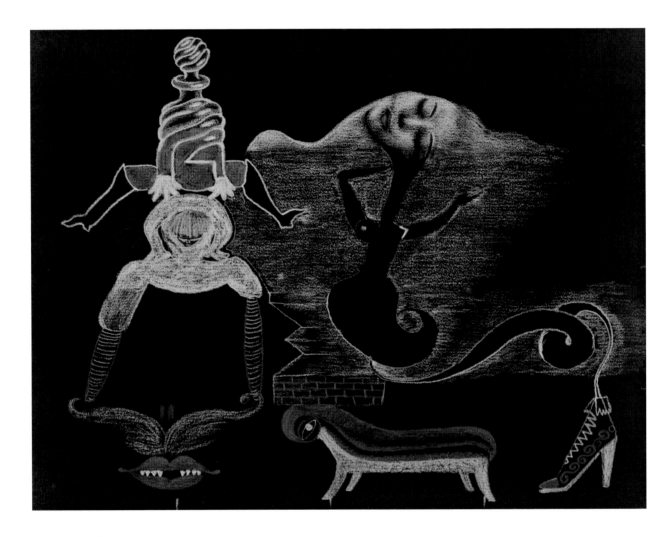

away from the anarchic nihilism of Dadaism towards the more politically engaged position of Surrealism.

The FATAGAGA project prefigured one of the Surrealists' favourite group practices, the *'cadavre exquis'* (exquisite corpse). Valued highly for the element of chance in its genesis, the *cadavre exquis* proved to be one of the Surrealists' most fruitful games, and – as games were undertaken with the utmost seriousness – was seen as a genuine form of Surrealist expression. One participant would start drawing a head, fold the paper and pass it on to his neighbour, who would only get to see two lines leading from the head over the fold. He or she would add a torso and fold the paper again for the next person to draw the legs. In this way no-one would have seen what the previous participant had drawn, the result being a highly heterogenous 'figure'. The appeal of this game derived as much from the element of chance as from its collaborative character, and resulted in a large number of surviving drawings which have since gained the status of genuine artworks.

ANDRÉ BRETON AND HIS CIRCLE: THE MEETING OF FRIENDS

In February 1919, three young men, André Breton, Philippe Soupault and Louis Aragon, gathered at Breton's temporary residence, Hotel des Grands Hommes on Place du Pantheon, Paris. Not yet discharged from military service, the three planned to set up a new literary review, *Littérature*, to promote their own poetry as well as to publish the works of other poets they revered. They were joined by Paul Éluard in March 1919 and together they would stroll through the streets of Paris, or meet at the Café de Flore to discuss literature, art and psychology. *Littérature* was the outlet for their anger against a society which they felt was to blame for the war.

By 1922 Breton and Soupault had moved away from Dadaism towards a new artistic expression that was to be one of the main pillars of Surrealist practice: '*ecriture automatique*' (automatic writing). The technique of automatic writing – which they adopted for their jointly written novel *Les champs magnétiques* (The Magnetic Fields) – attempted to unveil subconscious imagery by jotting down text as fast as possible in order to prevent any conscious decision about its content. Soupault later claimed that as soon as the brain has been deprived of its logic functioning, the outcome would almost invariably be an image.[6] It was this kind of spontaneous imagery that attracted the Surrealists and influenced their theories on the superior reality of chance and dream.

The *Littérature* group featured prominently in Max Ernst's largest painting to date, *Au rendez-vous des amis* (A Friends' Reunion). It was painted in autumn 1922 as an homage to his new Parisian acquaintances, who appear among spiritual friends and predecessors,

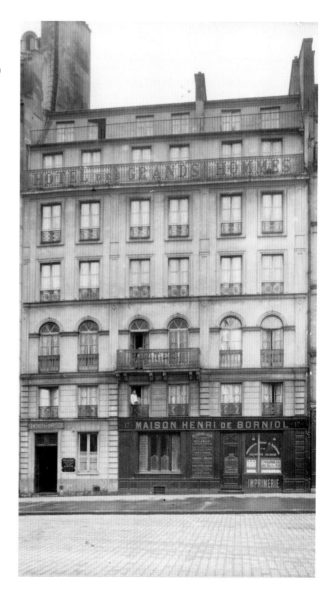

such as Fyodor Dostoyevsky, Giorgio de Chirico and, rather unexpectedly, Raphael. Whereas de Chirico's presence in the painting was a reference to his importance as the revered inventor of metaphysical painting, the presence of the Renaissance master is the key to the interpretation of this complex painting: Ernst based the scheme of his group portrait on Raphael's *Disputa* (Dispute Over the Sacrament), likening this meeting of young intellectuals to the dignified congregation of debating churchmen.

Heading hurriedly towards the centre of the composition is André Breton, whose raised arm repeats the gesture of the prophet next to the altar in Raphael's painting. By presenting Breton in the guise of a high priest Ernst anticipated his future role as the authoritarian leader of Surrealism. A curious and telling void

André Breton and his Circle: the Meeting of Friends

Max Ernst, *Au rendez-vous des amis*
(A Friends' Reunion). Oil on canvas.
1922. Museum Ludwig, Cologne

between Breton and the other central figure of Ernst's painting, Paul Éluard, replaces the altar which dominates Raphael's mural. A special role was assigned to Gala Éluard, whose posture imitates that of a young man in the foreground of *Disputa*. By moving her to the periphery, Ernst was highlighting her independence from the group. Her husband, Paul Éluard, appears with a clenched fist, which is contradicted by his contemplative expression and contrasts with Breton's lofty gaze towards the viewer.

To underline the solemn occasion of this important meeting, all of the protagonists are dressed in colourful suits, arranged in front of the majestic setting of the Alpine panorama where Ernst had first met his new friends. Jean Arp serves as a link between new and old acquaintances, with his hand resting on the roof of a stage that represents the Café Voltaire where everything began. With Aragon (behind Breton) and Soupault (second from left), Ernst included the founding members of *Littérature*, with Johannes Baargeld (second from lower right) an important member of the Cologne Dada group, and Rene Crevel (far left) the future link between Surrealism and the Communist party. Gathered under the auspicious sign of a rare stellar constellation, the group of future Surrealists was presented in full awareness of its rising importance.

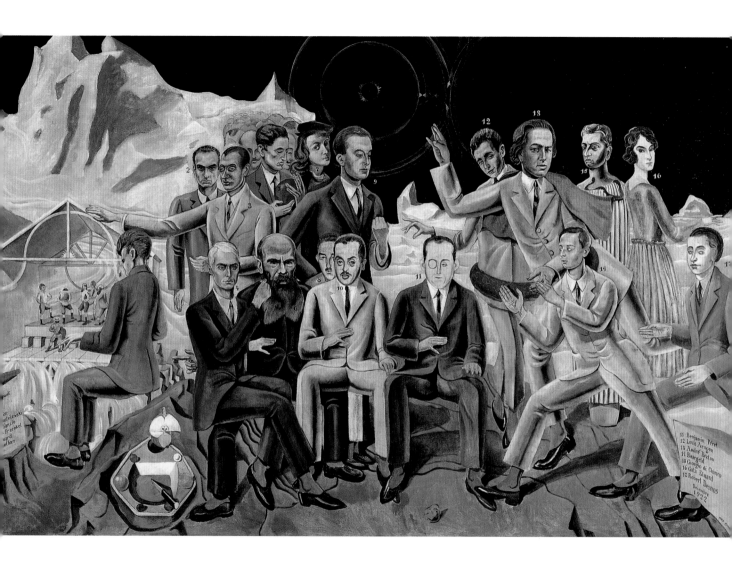

11 Benjamin Péret
12 Louis Aragon
13 André Breton
14 Baargeld
15 Giorgio de Chirico
16 Gala Éluard
17 Robert Desnos
December
1922

PAUL ÉLUARD AND MAX ERNST: EAUBONNE

Paul Éluard and Max Ernst met in Cologne in 1921 and developed a mutual affection that resulted in a life-long friendship. As immediate as their rapport was the sexual attraction between Ernst and Gala Éluard, who plunged into an affair that Éluard himself acknowledged, famously commenting that he loved Ernst much more than Gala. When the two families reunited for a vacation in Tirol the following summer it became obvious that Ernst would leave his family and follow Gala and Paul to Paris. He crossed the French border with the help of Paul's passport to live with the Éluards in Saint Brice and, supplied with the false identity of 'Jean Paris', obtained a work permit that would allow him to support himself as a worker in a souvenir factory.

In April 1923, Paul Éluard bought a three-storey house with a garden in the suburb of Eaubonne, and as soon as the Éluards and Ernst had moved in, Ernst embarked on the decoration of several rooms with a series of murals that would both reveal and veil the dynamics of the *ménage à trois* under its roof. It is likely that Éluard and Ernst jointly devised the decoration, even though no notes, sketches or preparatory drawings have survived. There are indications that the colour scheme of each room was based on the respective floor tiling, starting with a bright golden-yellow on the ground floor, beige and blue on the staircase, and blue, red and green on the second floor. The exact iconography of some of the paintings has defied interpretation, but there is no doubt that the overall theme revolved around the entwined relationships of the inhabitants of the house.

Following Éluard's and Ernst's collage book *Les malheurs des immortels* (The Misfortunes of the Immortals),

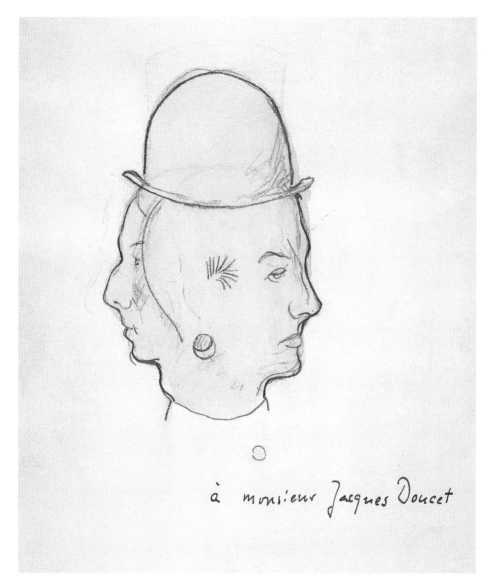

à monsieur Jacques Doucet

Max Ernst, Double portrait of Ernst and Éluard. Pencil and ink on paper. 1922. Bibliothèque littéraire Jacques Doucet, Paris

Paul Éluard and Max Ernst: Eaubonne

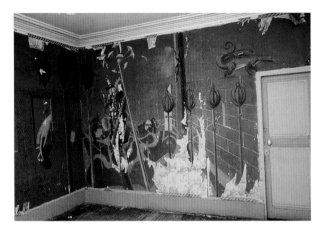

Above: Gala and Paul Éluard's bedroom at Eaubonne. Contemporary photographs with the murals by Max Ernst revealed

Right: Max Ernst, *Au premier mot limpide*. Oil on plaster, mounted on canvas. 1923. Kunstsammlung Nordrhein-Westfalen, Düsseldorf

Opposite: Max Ernst, *Histoire Naturelle*. Oil on plaster, mounted on canvas. 1923. Museum of Contemporary Art, Tehran

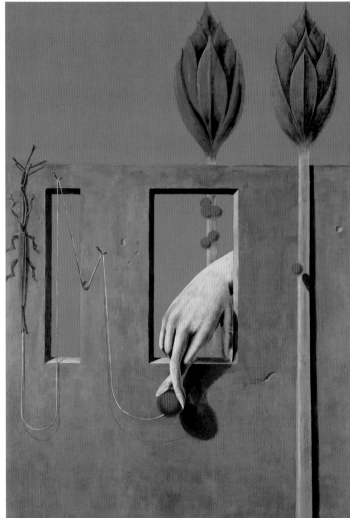

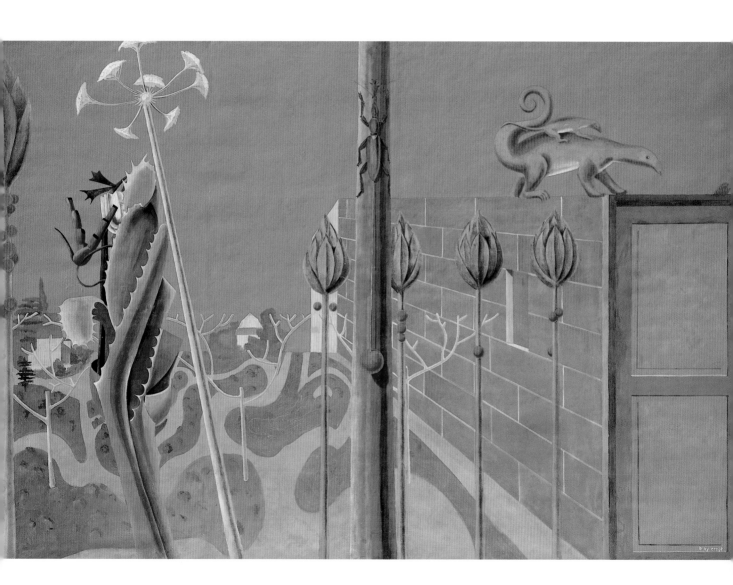

Paul Éluard and Max Ernst: Eaubonne

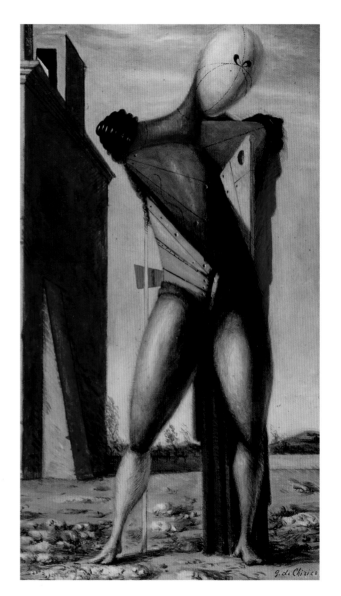

a joint venture in collaborative writing carried out the previous year, it seems likely that the paintings were based on Éluard's poetry. This was certainly the case with the door that led from the entrance hall into the living room: the hands, reaching out towards a tree from which a heart is hanging, seem to illustrate a line from *Répétitions* (Repetitions) which Éluard had published earlier that year: '*Le cœur sur l'arbre vous n'aviez qu'a cueillir*' (The heart on the tree you have only to pick it). In a photograph from 1924 Max can be seen in front of the door, entertaining Gala Éluard and her daughter Cécile, who sit under De Chirico's *Il Trovatore* (The Troubadour), which the Éluards had bought from the artist on their visit to Italy in December 1923.

The *ménage à trois* ended abruptly in 1924 with Paul Éluard's disappearance from Paris, leaving Gala

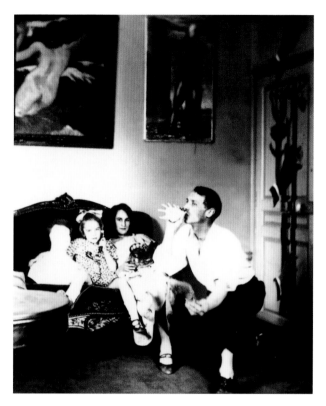

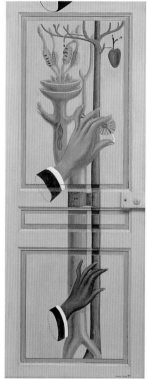

and Ernst behind as he travelled to South-East Asia.
When he resumed contact, the two decided to travel to
the Far East themselves and persuade him to return. Ernst
withdrew from the relationship following the reconciliation
of Gala and Paul. They continued to live in Eaubonne
until Gala's fateful encounter with Salvador Dalí in 1929
which spelled the end of their marriage. Éluard sold the
house in 1932 and the murals remained hidden under
wallpaper until 1967.

MAX ERNST AND JOAN MIRÓ: ROMEO AND JULIET

In March 1926, Joan Miró moved to Rue Tourlaque, Paris, to be the new neighbour of Max Ernst, Jean Arp and Paul Éluard. Sharing Ernst's studio for a short period until he could move into his new place, the two established a close working relationship, despite their contrasting characters. Both were exploring automatic techniques in their work. Miró was experimenting with automatic painting methods with André Masson, which had developed from the practice of automatic writing, prompting Breton to hail Miró as 'probably the most Surrealist of us'.[7] Max Ernst, meanwhile, had developed an automatic technique named 'frottage'. Inspired by the sight of a wooden floor he took a piece of paper, pressed it against the wood beams, and by gently rubbing chalk or pen over its surface revealed the 'hallucinatory effect' of its pattern. This chance imagery

was the starting point for his cycle of drawings Histoire Naturelle (Natural History).

When Boris Kochno, the assistant producer of the Ballets Russes, visited Ernst's studio, he found both artists at work. Returning to Diaghilev, director of the ballet company, the next day, he confessed that he wasn't sure what to think about their art. Diaghilev, however, prompted by Picasso, decided to commission Ernst and Miró to paint the sets for his upcoming production of Romeo and Juliet.

No account of Diaghilev's reaction to the result of the collaboration has survived, but if he was surprised by the imagery Ernst and Miró came up with he certainly did not show it. Miró, responsible for the front cloth and backdrop for Act One, contributed a Dream Painting. Enlarged for the front cloth it showed a fragile

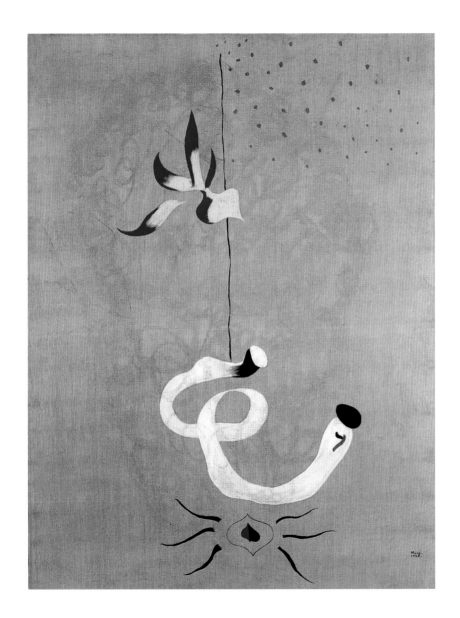

Joan Miró, *Dream Painting*, front cloth for *Romeo and Juliet*. Oil on linen. 1925. Wadsworth Atheneum

Max Ernst and Joan Miró: Romeo and Juliet

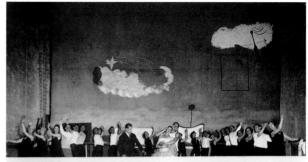

Right: Rehearsal of *Romeo and Juliet* in front of Miró's backdrop. 1926. Musée national d'art moderne, Centre Georges Pompidou

Opposite: Joan Miró, Study for the stage design of *Romeo and Juliet*, detail. Gouache and pencil on cardboard. 1926. Wadsworth Atheneum

construction with a burning heart hovering above it. Ernst's contribution for the drops for Act Two were two enlarged *frottages*, *The Sea* and *The Night*, whose powerful horizontal shapes contrasted strongly with the fragility of Miró's designs. Visibly, the close collaboration of the two artists did not result in any stylistic analogies, but for those sensitive to Surrealist aesthetics the contrast symbolized exactly the main theme of the play: bridging the seemingly unbridgeable.

Following a warm reception of the ballet at its first performance in Monte Carlo, the Paris première on 18 May 1926 ended in chaos: just after the lights had been dimmed and the orchestra was about to begin, thirty or forty young men rushed up the central aisle blowing whistles, while others hollered at the top of their voices, strewing about leaflets which denounced Ernst and Miró's

participation as a betrayal of Surrealist ideals. The protest had been organized by André Breton and Louis Aragon, who had also written the leaflet. Breton's anger had been fuelled by a remark Picasso made after hearing of the collaboration he himself had contrived: 'I hear that your colleagues are working for Diaghilev? That's a fine state of affairs. The moment you see a cheque you collaborate with reactionary white Russians. So much for that famous rigour of yours!' [8]

On behalf of Miró and himself, Ernst responded to Breton's protest, accusing him of being 'the principal shareholder in a commercial association of revolutionary artists', and the movement of having become 'a church' that had lost its revolutionary importance.[9] Only the intervention of Paul Éluard reconciled the two artists with the movement, but an irreparable divergence of attitude remained.

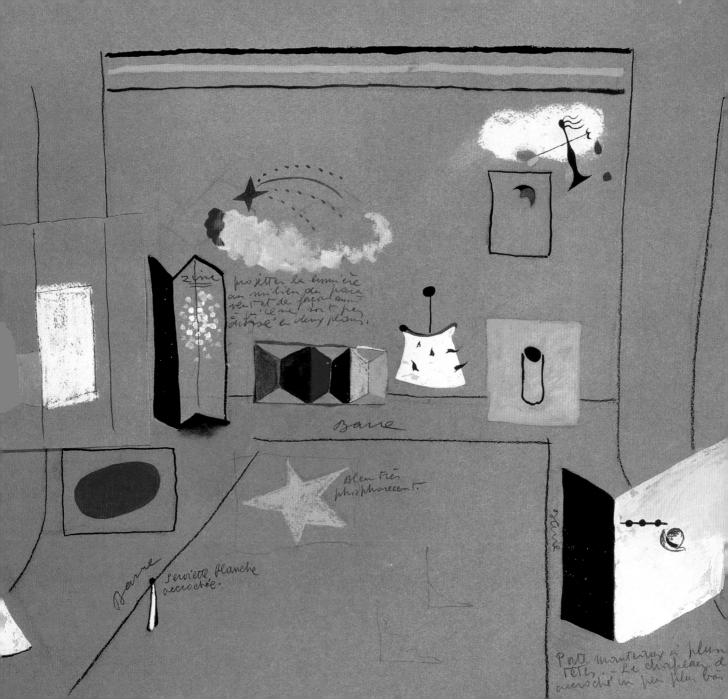

Max Ernst and Joan Miró: Romeo and Juliet

Opposite: Max Ernst, *The Sea*, backdrop for *Romeo and Juliet*. Oil on fabric. 1926. Wadsworth Atheneum

Left: Max Ernst, *The Night*, backdrop for the balcony scene, *Romeo and Juliet*. Oil on fabric. 1926. Wadsworth Atheneum

JEAN ARP AND ALBERTO GIACOMETTI: DISAGREEABLE OBJECTS

In spring 1930, Pierre Loeb staged a group exhibition, *Miró – Arp – Giacometti*, which turned out to be an unofficial Surrealist showcase. Two of the artists exhibited, Arp and Miró, were loosely connected with the Surrealist movement, but despite encouragement from Breton's side were reluctant to commit themselves fully to his agenda. The third artist, Alberto Giacometti, was soon to join the movement and would immerse himself fully in its activities for the following four and a half years.

It was at this exhibition that Breton saw and immediately acquired the *Boule suspendue* (Suspended Ball), which Giacometti had contributed to the exhibition as his most recent work. Its sexual connotation was immediately registered, and Dalí eloquently praised the work in the following issue of *Le Surréalisme au Service de la Revolution*: 'A wooden ball with a feminine cleft hangs on a thin violin string over a crescent shape whose sharp edge almost touches the cavity. The spectator is moved instinctively to make the ball slide onto the sharp edge, but the length of the string only allows him partially to achieve this.' [10]

Giacometti, who had arrived in Paris seven years earlier but had mostly remained within a circle of Swiss artists, was delighted to find himself suddenly at the centre of attention; Jean Arp, meanwhile, had just turned from making wooden reliefs to his earlier practice of creating sculptural objects. Both artists now started exploring a new direction in their work, which they referred to as objects rather than sculptures. Arp's *Objets*

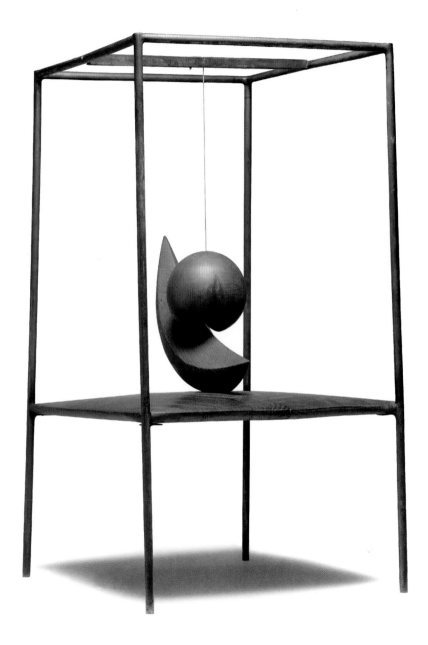

Alberto Giacometti, *Boule suspendue* (Suspended Ball). Wood, iron and string. 1930. Musée national d'art moderne, Centre Georges Pompidou

Jean Arp and Alberto Giacometti: Disagreeable Objects

désagréables sur une figure (Disagreeable Objects On A Figure) and Giacometti's *Objet désagréable à jeter* (Disagreeable Object To Be Thrown Away) aimed to turn a sensation of discomfort into a sculptural object. Giacometti's piece emerged as a reaction against his previous work, which he dismissed as 'too precious, too classical' and not fitting into a reality as he perceived it. Everything in his work at this time seemed to him 'slightly grotesque, without value, to be thrown away'. He thought that sculptural form should be the expression of emotions rather than the depiction of an existing external form. It was this statement that opened the door for the Surrealists' interpretation of Giacometti's sculptures as oscillating between sexual imagery and aggression, thus as a Freudian imagery of suppressed anxiety.

Left: Jean Arp, *Objets désagréables sur une figure* (Disagreeable Objects On A Figure). Plaster. 1930. Kunstmuseum Silkeborg, Denmark

Below: Alberto Giacometti, *Objet désagréable à jeter* (Disagreeable Object To Be Thrown Away). Bronze. 1931. Kunsthaus Zürich

GALA ÉLUARD AND SALVADOR DALÍ:
'GALA-SALVADOR DALÍ'

The meeting of Gala Éluard and Salvador Dalí in the summer of 1929 marked the beginning of one of the most notorious collaborative partnerships of twentieth-century art. Gala abandoned her husband Paul and soon assumed the roles of Salvador's lover, muse, agent, model and alter ego until her death in 1982. Refusing to deal with anything that lay in her past, Gala left behind no account of her life, her actions or aspirations, leaving it to a few surviving letters and Dalí's notoriously unreliable autobiography, *The Secret Life of Salvador Dalí*, to explain the nature of their relationship. What is reliable, though, is Dalí's personal iconography, in which Gala plays a central role: the number of portraits of her is considerable, transforming her face and body into part of the twentieth-century pictorial canon. Dalí himself considered their encounter a turning point

in his life, as the ample account of the events in his autobiography reveals.

Dalí and Paul Éluard had been introduced by Camille Goemans the previous winter, and Dalí, fully aware of Éluard's importance as a promoter of contemporary art, invited him and Gala to Cadaqués where Dalí's family owned a summer house. Intrigued by the prospect of cheap holidays in Spain, Éluard accepted and arrived with his wife in early August. They shared their hotel not only with the Goemans, but also with René Magritte and his wife Georgette. The last to arrive at Cadaqués was Luis Buñuel, with whom Dalí had recently collaborated on his film *Un chien andalou* (An Andalucian Dog). Buñuel later remembered that Dalí literally changed overnight after meeting Gala. When the group left for Paris in September, Gala stayed on,

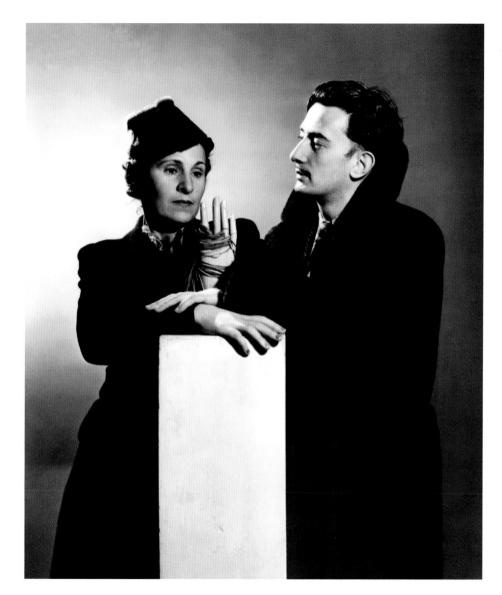

Man Ray, Gala and Salvador Dalí.
Photograph. 1936. Man Ray Trust

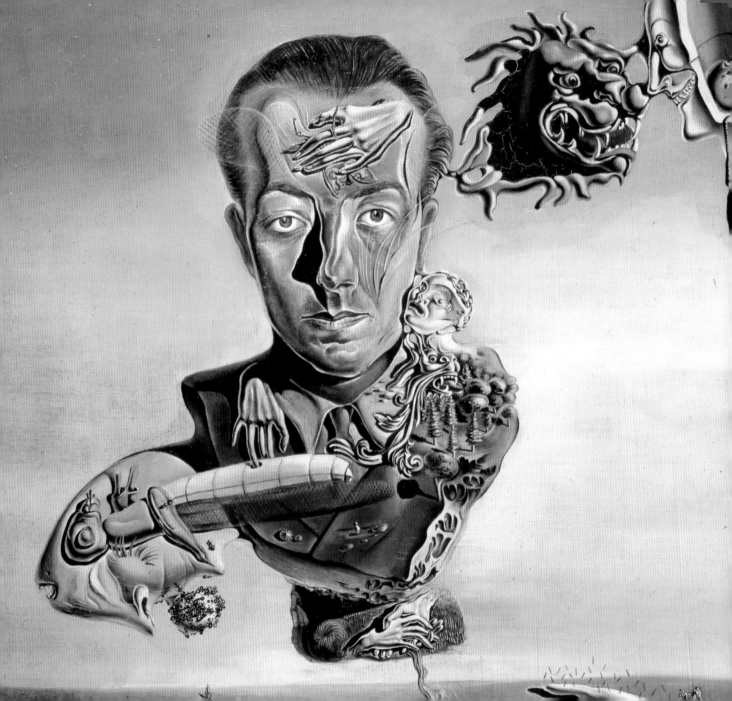

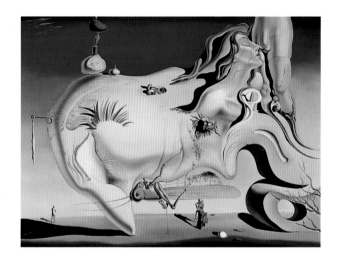

Opposite: Salvador Dalí, Portrait of Paul Éluard. Oil on cardboard. 1929. Private collection

Left: Salvador Dalí, *Le grand masturbateur* (The Great Masturbator). Oil on canvas. 1929. Museo Nacional Centro de Arte Reina Sofía, Madrid

and within a few months had assumed her future role as Dalí's muse and manager.

Dalí's eloquently mythicized claim that Gala had saved him from sexual paralysis is immortalized in several paintings, most notably *Le grand masturbateur* (The Great Masturbator), which he began working on immediately after their encounter. The central element of the painting is a 'petrified couple', in fact the bust of a woman with closed eyes in front of a man's torso, seemingly engaging in the act of fellatio. The two figures grow out of the soft form of a grotesque face, hovering over a flat landscape. A locust, ants and a lion's head are menacingly displayed above a small kissing couple. These elements also appeared in another painting, which Dalí might have begun slightly earlier. Shortly after the arrival of his guests Dalí had embarked on a portrait of Paul Éluard, which introduced several

elements of *Le grand masturbateur*. Here the grotesque face with its closed eyes appears as part of the painted bust of Éluard, with the locust as a link between bust and head. The roaring lion faces a mask housing a broken egg.

Despite its web of painted biographical references and a cast of beasts derived from his own dream imagery, Dalí's pictorial language, mostly circling around his suddenly aroused desire, is not difficult to read: Gala's role in his myth was prominently symbolized by the bust of the female part in the petrified couple in *Le grand masturbateur*. Over the years Dalí would often depict her as interchangeable with himself, highlighting the fact that his inspiration had its source in her existence. The collaborative relationship, in which both partners proved to be indispensable for each other, was symbolized by Dalí's habit of signing his works 'Gala-Salvador Dalí'.

LEE MILLER AND MAN RAY: INDESTRUCTIBLE OBJECT

In summer 1929, Lee Miller, a twenty-five-year-old art student from New York, introduced herself to Man Ray, informing him that she was his new photography student. Man Ray, obviously not unaffected by the beauty of his new acquaintance, readily accepted her as a student and not long afterwards as a lover. Lee Miller proved to be a gifted photographer and an undemanding assistant to the overworked Man Ray, who would often pass on assignments to her in order to free himself for painting. Miller had been a model for various fashion photographers since 1927, and would feature prominently in Man Ray's photography during the period of their professional and personal relationship.

Much to Man Ray's distress, the relationship soon turned into dependence on his side, and when she left him in early summer 1932 he staged his suicide threat in a

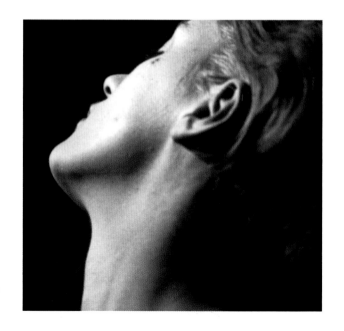

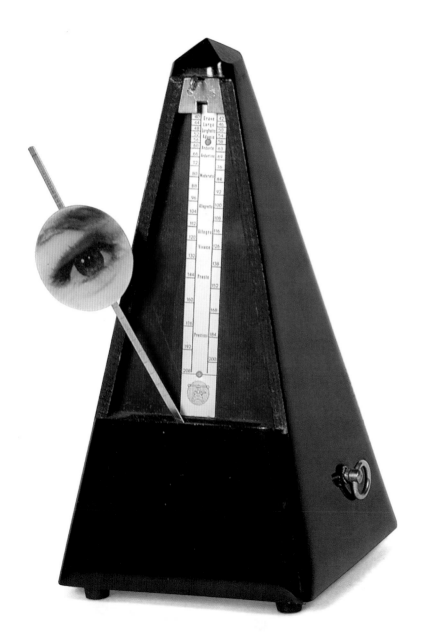

Opposite: Man Ray, Lee Miller (neck). Gelatin silver print. *c.*1930. Man Ray Trust

Left: Man Ray, *Objet Indestructible* (Indestructible Object). Metronome and photograph. 1932–65. Man Ray Trust

Lee Miller and Man Ray: Indestructible Object

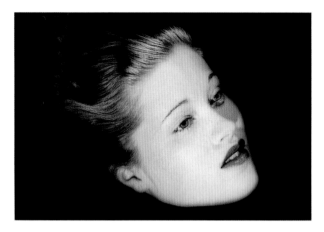

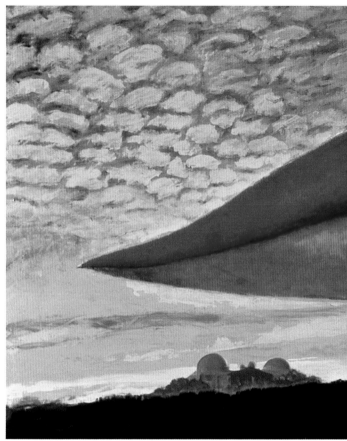

photograph in which he could be seen holding a revolver against his forehead, with a rope around his neck and a glass presumably filled with poison on the table before him. In the course of the following months he produced several works, the theme of all of which was his own loss. One was *Objet indestructible* (Indestructible Object; also Object of Destruction, or Do Not Destroy), with an image of Lee Miller's eye clipped to the pendulum of a metronome; another was the large painting *À l'heure de l'observatoire – les amoureux* (Observatory Time – The Lovers), in which the apparition of Lee Miller's lips floats over the Montparnasse observatory. Passing the observatory on his way to and from the studio every day, Man Ray imagined its two domes as upright breasts. By painting them under the floating lips he more than obviously attempted to deconstruct the loved and lost body of Lee Miller.

Above left: Lee Miller, *Floating Head (Mary Taylor)*. Photograph. 1933. Lee Miller Archives

Above: Man Ray, *À l'heure de l'observatoire – les amoureux* (Observatory Time – The Lovers). Oil on canvas. 1932–4. Private collection

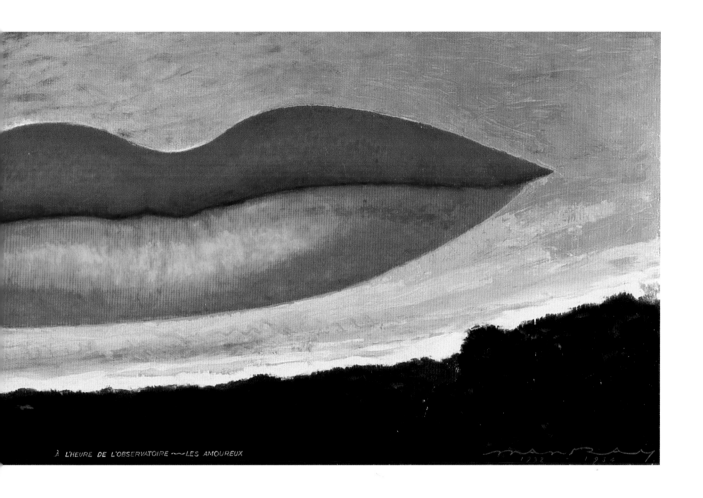

À L'HEURE DE L'OBSERVATOIRE ~ LES AMOUREUX

MARCEL DUCHAMP AND MARY REYNOLDS: UBU ROI

Throughout the 1920s, Marcel Duchamp had been what could best be described as a distant participant in Surrealism: a friend of its protagonists, he promoted their work but very rarely participated in their activities. Reluctant to tie himself too firmly into any circle or obligation, he had pursued his main interest – playing chess – and acted as an art advisor to various collectors.

His desire for independence extended into his private life, where he tried to hide his relationship with Mary Reynolds for almost a decade. Mary Reynolds and Duchamp met in New York in 1917 and renewed their acquaintance in 1923 when both moved to Paris. In the course of considerable time spent together socializing at the *Boeuf Sur le Toit*, their somewhat complicated relationship evolved. Duchamp insisted that it had to be kept secret and continued to have affairs with others, expecting her to do the same. It was only after his short-lived marriage that he allowed their relationship to become public.

Despite the complexities of their personal life, they developed a collaborative partnership which fused the artistic language of both. In 1934 they embarked on a bookbinding for Alfred Jarry's play *Ubu Roi* (King Ubu), which Duchamp had designed earlier that year. Reynolds had trained as bookbinder at the atelier of Pierre Legrain, one of Paris's most innovative designers of the time. It took her almost a year to complete the work, but it pleased both so greatly that they decided to create a second copy, that was then acquired by the American collectors Walter and Louise Arensberg. The binding itself forms a Duchampian pun, with its front and back covers being cut out in the shape of

Man Ray, Mary Reynolds and
Marcel Duchamp. Gelatin silver
print. Art Institute Chicago

Marcel Duchamp and Mary Reynolds: Ubu Roi

a 'U', and the spine representing a 'B', reading 'UBU' when open. A small gold crown on black moiré silk ground is printed on the front flyleaf, being visible through the cut-out 'U'; the author's name is placed in the same position on the back.

Throughout the following ten years, Mary Reynolds produced several bindings for works by Duchamp, as well as others for authors from the Surrealist group, such as Man Ray, Paul Éluard and Raymond Queneau.

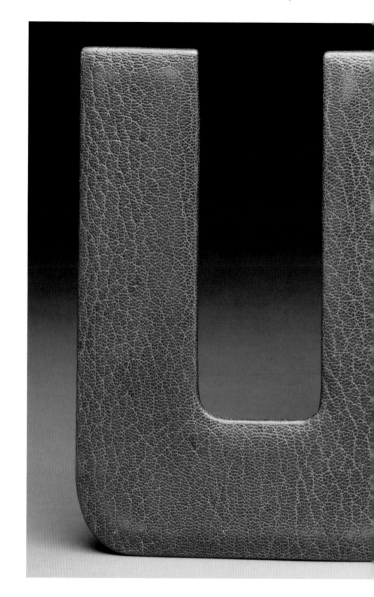

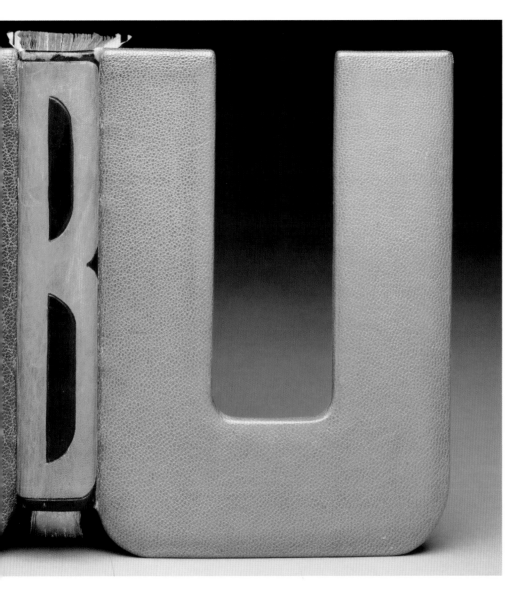

Opposite: Mary Reynolds and Marcel Duchamp, *Rrose Sélavy*. Bookbinding. 1939. Art Institute Chicago, Mary Reynolds Collection

Left: Mary Reynolds and Marcel Duchamp, *Ubu Roi* (King Ubu). Bookbinding. 1934–5. Art Institute Chicago

EXPOSITION SURRÉALISTE D'OBJETS

Left: Interior view of the *Exposition Surréaliste d'Objets*, Galerie Charles Ratton. 1936

Opposite: Marcel Jean, *Le spectre du gardénia* (The Spectre of the Gardenia). Plaster head with painted black cloth, zips, and strip of film on velvet-covered wood base. 1936–71. Private collection

Among the main forums for collaboration were the Surrealist exhibitions, to which the various members would not only contribute their works, but also ideas for display, catalogue texts and, increasingly, objects specially made for the occasion.

In May 1936, Breton organized the *Exposition Surréaliste d'Objets*. It opened in Rue Marignan, Paris, at the gallery of Charles Ratton, an art dealer who specialized in ethnographic art. It was to be the largest group show to date, with most of the active Surrealists participating. The exhibition celebrated what Breton called the 'poetic energy' of objects taken out of their customary environment. The catalogue, an eight-page leaflet, listed the exhibits under six categories: 'natural' objects, ranging from minerals to a carnivorous plant; 'found' objects of any kind; 'mathematical' objects; 'American' and 'Oceanic' masks and tribal art; and 'Surrealist' objects. The objects were displayed in a setting reminiscent of an ethnographic museum, to highlight the scientific sincerity with which the Surrealists intended to explore the subject.

Alberto Giacometti was represented with *Boule suspendue* (Suspended Ball), a sign that the rupture between himself and Breton had not lessened the latter's esteem for his work. Marcel Jean had created *Le spectre du gardénia* (The Spectre of the Gardenia), a cast of Houdon's bust of Madame Dubarry covered with flakes of black wool powder, whose eyelids were replaced by a pair of zips. These could be

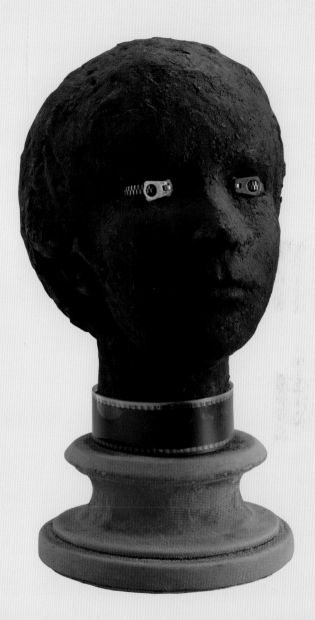

Exposition Surréaliste d'Objets

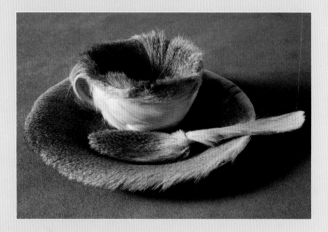

moved like pupils, thus changing the expression of the face. When the zips where half opened, two miniature photographs of a star and a face could be seen. Leonor Fini's *Couverture d'un Livre* (Cover of a Book) was listed as an *objet trouvé* (found object), but was in fact a shell-encrusted reprint of Columbus's logbook, implying voyage and discovery.

One of the most celebrated objects in the exhibition was Meret Oppenheim's *Tasse, soucoupe et cuiller revêtues de fourrure* (Teacup, Saucer and Spoon Covered in Fur), immediately purchased by Alfred Barr for the Museum of Modern Art, New York, which proved to be the imposing icon of Surrealism from the date of its first display at the *Exposition* in mid-May 1936. André Breton suggested the more sexually charged title *Le déjeuner en foururre* (Breakfast in Fur),

a pun on Manet's *Déjeuner sur l'herbe* and Sacher-Masoch's *Venus in Furs*.

The fur teacup was preceded by a fur bracelet, which Oppenheim had created for Schiaparelli's winter collection. Wearing such a bracelet she met Dora Maar and Picasso at the Café Flore, and marvelling at the extravagant piece the three jokingly discussed the possibility of covering anything in fur.[11] Oppenheim did not need any encouragement from Picasso (interestingly, most literature attributes the suggestion to him), since the fur cup, which she is said to have created after the three-way discussion, belongs to a whole group of fur-lined objects made around this time. Besides the bracelet a pair of fur gloves from 1936 and a drawing with projected fur-lined sandals show how Oppenheim explored the theme of nature versus culture before turning it playfully into a true Surrealist object.

Meret Oppenheim's participation in the Surrealist movement was a short and intense one. When she moved to Paris in 1932, aged eighteen, she almost unwillingly attained the position of a symbolic figure, both as an artists' and as a photographers' model. Much to her later chagrin it was to be two iconic works which persistently overshadowed most of her later work. One was the *Tasse, soucoupe et cuiller revêtues de fourrure*; the other was a series of photographs taken in 1933 by Man Ray in the printing studio of Louis Marcoussis, where she posed nude at the printing press wheel. Having become a Surrealist object herself, she later struggled not to be seen as simply the muse of a movement whose main participants were on average fifteen years her seniors.

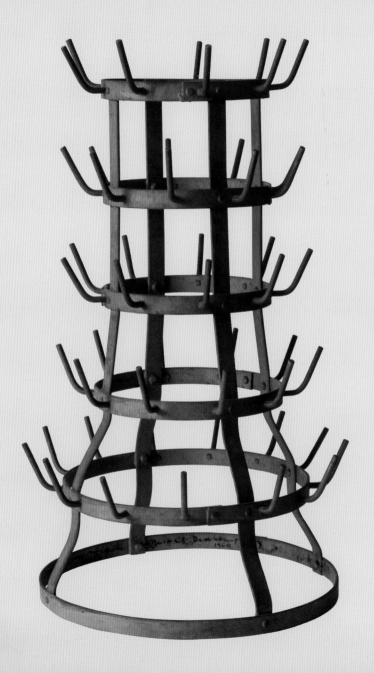

Opposite: Meret Oppenheim, *Tasse, soucoupe et cuiller revêtues de fourrure* (Teacup, Saucer and Spoon Covered in Fur). 1936. Museum of Modern Art, New York

Left: Marcel Duchamp, *Porte-Bouteilles* (Bottle Rack). Galvanised iron. 1914/1960. Robert Rauschenberg Foundation

Below: Leonor Fini, *Couverture d'un livre* (Cover of a Book). 1936. Private collection

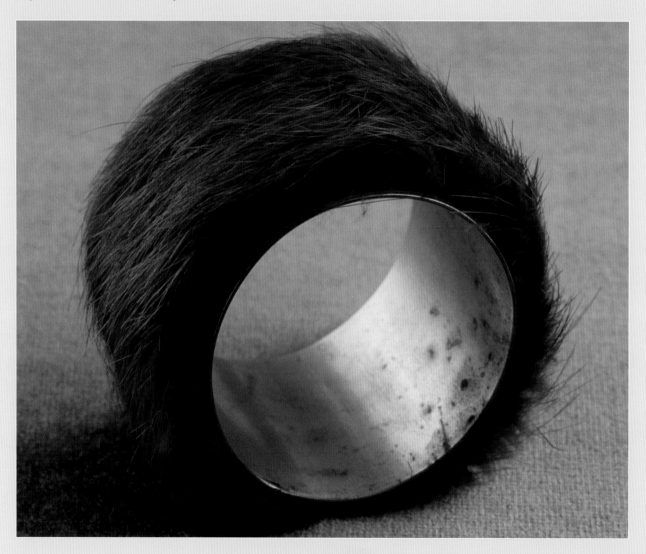

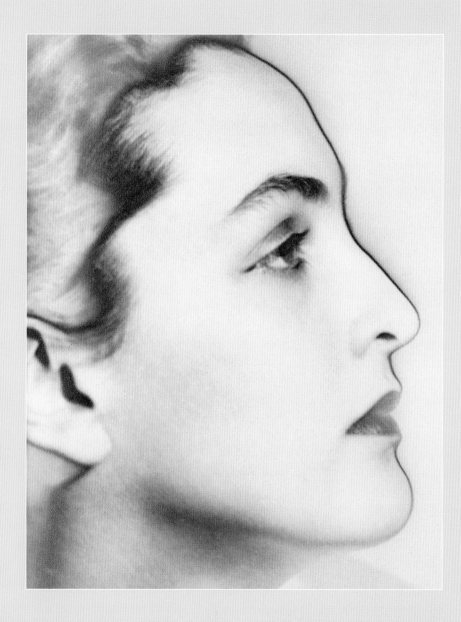

Opposite: Meret Oppenheim,
Fur Bracelet. Fur (beaver). 1935.
Private collection

Left: Man Ray, Portrait of Meret
Oppenheim. Photograph. 1933.
V&A: PH.68–1984

EILEEN AGAR AND PAUL NASH: SEASIDE SURREALISM

In the summer of 1935, Eileen Agar met Paul Nash in Swanage, where Nash lived at the time. Nash had recently developed an interest in found objects, which corresponded to Agar's previous work as a collagist and her own use of found material. The new aspect which both artists began to explore during this summer was beachcombing. One found object which came to prominence in the work of both artists was a 'seashore monster' discovered by Agar in Lulworth Cove. Its long, snake-like body with a beaked head featured in Nash's article 'Swanage or Seaside Surrealism', published the following spring in the *Architectural Review*,[12] as well as in his collage *Swanage*.

Following a recommendation by Paul Nash, Roland Penrose and Herbert Read visited Agar's studio early in 1936 and selected several of her paintings and objects for the International Surrealist Exhibition of that year. Agar's ambivalence to the movement was clear in the often quoted remark: 'One day I was an artist exploring highly personal combinations of form and content, and the next I was calmly informed I was a Surrealist!'[13]

The International Exhibition turned out to be a huge success, as Agar recalled in her memoirs:

The International Surrealist Exhibition was well-timed, and that very hot summer the New Burlington Galleries became a new source of wonder as we made living contact with the materializations of strong spiritual forces, and sought to hunt down the mad beast of convention. You turned into Burlington Gardens, symbolically between the Royal

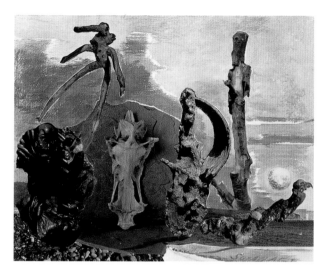

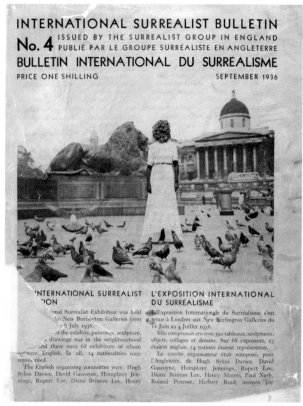

INTERNATIONAL SURREALIST BULLETIN
No. 4 ISSUED BY THE SURREALIST GROUP IN ENGLAND
PUBLIÉ PAR LE GROUPE SURRÉALISTE EN ANGLETERRE
BULLETIN INTERNATIONAL DU SURREALISME
PRICE ONE SHILLING SEPTEMBER 1936

Academy and Bond Street, and took the lift to the third floor of an ordinary-looking building. After that the spectacle began. The large rooms were crowded with the works of de Chirico, Dalí, Duchamp, Brancusi, Giacometti, Klee, Miró, Picabia and Picasso amongst others...[14]

In the following years Agar incorporated found maritime objects in a variety of works. The *Ceremonial Hat for Eating Bouillabaisse* was one of these objects, made during a visit to the south of France in 1936: 'It consisted of a cork basket picked up in St Tropez and painted blue, which I covered with fishnet, a lobster's tail, starfish and other marine objects. It was a sort of Arcimboldo headgear for the fashion-conscious, and received a lot of rather startled publicity.' [15] In the spring of 1939, Agar and Joseph Bard travelled to the French Mediterranean coast, where she watched a fisherman disentangle a broken Greek amphora from his nets. She was given the piece and added a ram's horn she had found in Cumberland, together with a starfish and a shell, and assembled them into the last of her maritime assemblages, *Marine Object*.

Eileen Agar and Paul Nash:
Seaside Surrealism

Right: Eileen Agar, *Marine Object.*
Mixed media. 1939. Tate Gallery

Opposite: Eileen Agar,
*Ceremonial Hat for Eating
Bouillabaisse.* Assemblage. 1936.
V&A: T.168–1993

Previous page left: Paul Nash,
Swanage. Pencil, watercolour and
photographic collage on paper.
c.1936. Tate Gallery

Previous page right: Cover of the
International Surrealist Bulletin.
September 1936. NAL: PP.7.J

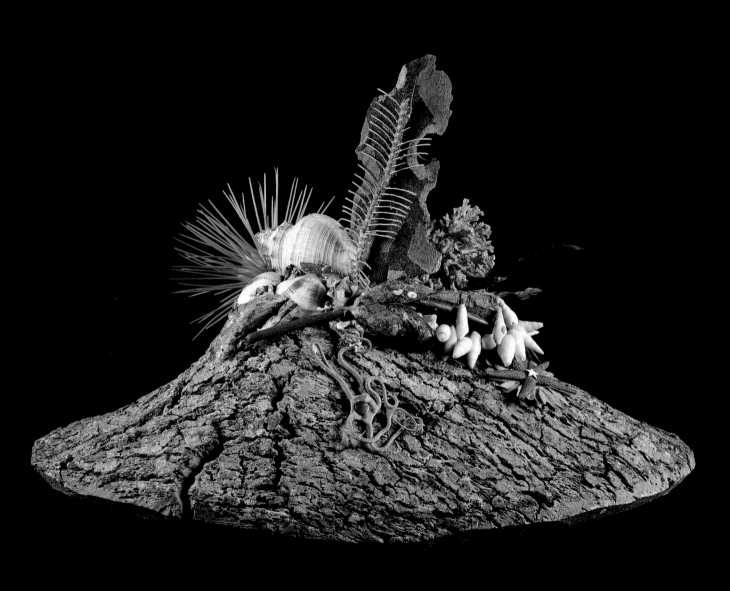

EDWARD JAMES AND RENÉ MAGRITTE: THE PLEASURE PRINCIPLE

Surrealism's most important English patron was Edward James, who inherited great wealth upon his father's death in 1912. Initially an aspiring poet, he was able to pursue his aesthetic interests freely, including a short career as a ballet impresario after falling in love with the Austrian performer Tilly Losch, with whom he had a short and disastrous marriage. Following the example of French friends such as the de Beaumonts and the de Noailles, he began to sponsor contemporary artists, many of whom he met through Marie Laure de Noailles in the early 1930s. From this time dates his contact and subsequent friendships with Dalí and René Magritte.

At the beginning of his relationship with Magritte, Edward James sent the artist a rare copy of his poems, obviously wishing to introduce himself to Magritte as a poet rather than a collector. From then on James

Opposite: Norman Parkinson,
Edward James with René Magritte's
L'avenir des statues. Photograph.
c.1937. Edward James Foundation,
West Dean

Right: René Magritte, *L'avenir des
statues* (The Future of Statues).
Painted plaster. 1937. Tate Gallery

and Magritte had a prolific exchange of letters,
sharing their mutual thought processes while at work.

Remarkably, the relationship between James and
the artists he sponsored turned out to be a highly
collaborative one, since James's playful fantasy
responded creatively to Surrealist practices. During his
friendship with Dalí he initiated plans for interiors,
paintings and objects, including the iconic lobster
telephone and the lips sofa.

Consequently James was no ordinary sitter when
it came to portraiture. Early in 1937 he commissioned
Magritte to paint his portrait, which would show him
standing in front of a mirror, facing the back of his
head. The painting, a *'portrait manqué'* (missed portrait),
was based on a photograph showing James in front of
Au seuil de la liberté (On the Threshold of Liberty),

Edward James and René Magritte: The Pleasure Principle

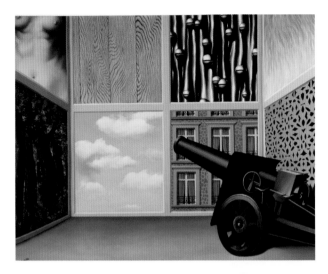

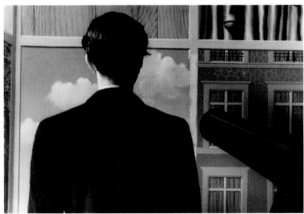

another commission from that year, which depicted a cannon aimed at the abdomen of a female torso. For the photograph James wittily placed himself in the firing line of the cannon, exaggerating the image of someone holding a gun against his head.

La reproduction interdite (Reproduction Prohibited) was shortly followed by *Le principe du plaisir* (The Pleasure Principle), this time based on an idea sketched by Magritte in pen the previous year and executed as a painting. During Magritte's stay at Wimpole Street in early 1937, James and Magritte seem to have discussed the idea of turning this painting into another *portrait manqué* of James. For this Magritte drew another sketch in May 1937, which was meant to instruct Man Ray on how to portray James during his visit to Paris. Man Ray slightly changed the arrangement by uncrossing James's arms, a change that Magritte adopted for his painting. The result of this tripartite Surrealist collaboration was an enigmatic portrait which concealed as much of the sitter as it revealed of the two artists involved.

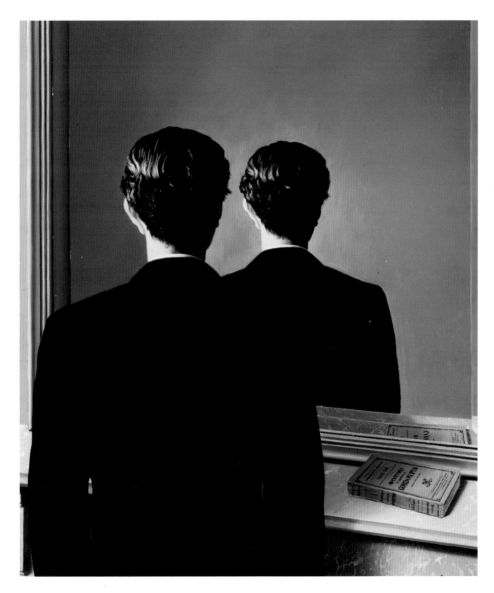

Opposite above: René Magritte, *Au seuil de la liberté* (On the Threshold of Liberty). Oil on canvas. 1937. Museum Boijmans Van Beuningen, Rotterdam

Opposite below: Edward James in front of *Au seuil de la liberté*. 1937. Edward James Foundation, West Dean

Left: René Magritte, *La reproduction interdite* (Reproduction Prohibited). Oil on canvas. 1937. Museum Boijmans Van Beuningen, Rotterdam

Edward James and René Magritte:
The Pleasure Principle

Opposite: René Magritte, *Le principe du plaisir* (The Pleasure Principle). Oil on canvas. 1937

Left: Man Ray, Portrait of Edward James. Photograph. 1937. Edward James Foundation, West Dean

EXPOSITION INTERNATIONALE DU SURRÉALISME

Opening on 17 January 1938 at the Galerie Beaux-Arts, the *Exposition Internationale du Surréalisme* was the most collaborative Surrealist event ever staged, encompassing all fields, from organization, object selection, mounting and interior design to the joint compilation of the *Dictionnaire abrégé du surréalisme* (Abridged Dictionary of Surrealism). This was published as the exhibition catalogue with illustrations by many of the contributors, but was in itself a retrospective of Surrealist thought and writing and thus emphasized the importance of the written word within Surrealism. The *Exposition* is one of the best documented exhibitions of its era, and through the involvement of many photographers it became a collaborative object in itself: Denise Bellon, Man Ray and Raoul Ubac, all of whom belonged to the Surrealist circle, photographed the exhibition during the installation and the opening.

The frontispiece of the exhibition checklist cited André Breton and Paul Éluard as the organizers, Marcel Duchamp as a 'generator-arbitrator', Dalí and Ernst as 'special advisors', Man Ray as 'master of lighting', and Wolfgang Paalen as responsible for 'water and brushwork'. It was not without his characteristic irony that Marcel Duchamp had assumed the title of an 'arbitrator', a position he had earned through his celebrated tact and skilled diplomacy when dealing with André Breton, whose temper had caused so many ruptures within Surrealism in the recent years. More importantly, his role as a 'generator' of ideas for the staging of the exhibition contributed largely to its success.

Indeed, the lasting fame of the *Exposition Internationale du Surréalisme* can be attributed mostly to its ambitious

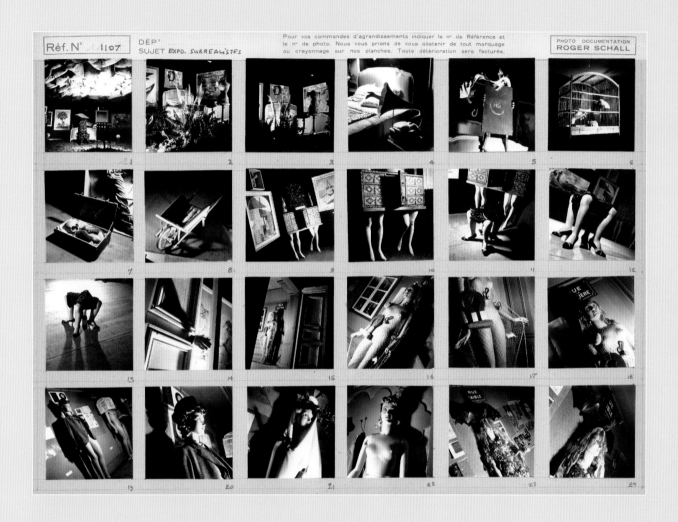

*The Exposition Internationale du
Surréalisme,* Galerie Beaux-Arts,
Paris, 1938. Collection Schall, Paris

Exposition Internationale du Surréalisme

Right: Wolfgang Paalen, *Paysage totémique de mon enfance* (Totemic Landscape of My Youth). Oil and fumage on canvas. 1937. Private collection

Opposite: see p.69, detail

interior design, which ensured the audience was repeatedly confronted with enigmatic encounters. Before entering the exhibition visitors passed Dalí's *Rainy Taxi*, a common Parisian cab with a scantily clad mannequin as passenger sitting under a continuous torrent of water. Upon entering, they were then confronted with a row of sixteen mannequins, each of them outfitted by a different artist and lined up along the corridor. These were mostly scarcely dressed, but equipped with the most fantastic accessories, from the bird cage worn over the head of Masson's mannequin, to Paalen's mannequin clad only in a coat of ivy and mushrooms. Behind most of the mannequins street signs had been mounted, some with actual Parisian street names, such as Rue Nicolas-Flamel, a medieval alchemist revered by Breton and Éluard, and some with invented poetic allusions, such as Rue de la transfusion du sang (Street of the Blood Transfusion), or Rue de tous les diables (Street of All the Devils). The installation of this part of the exhibition has been well documented, and much photographic material has survived, showing the Surrealists at work together, dressing (or undressing) their mannequins.

Having passed the queue of mannequins the visitors entered the central hall, where four beds with 'aphrodisiac night tables' seemed to await use. This largest space of the gallery had been transformed into a 'grotto' by Duchamp, who had covered the floor with sand, leaves and artificial puddles. The most striking feature, however, was the '1,200 coal sacks' which covered the ceiling of

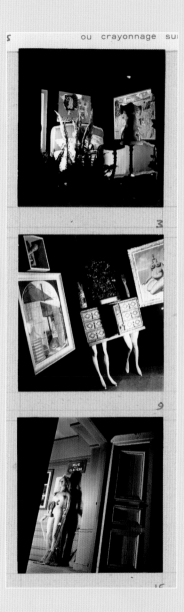

Exposition Internationale du Surréalisme

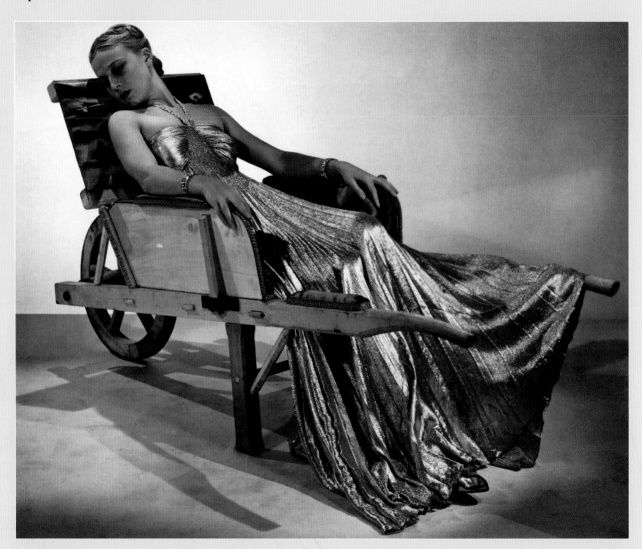

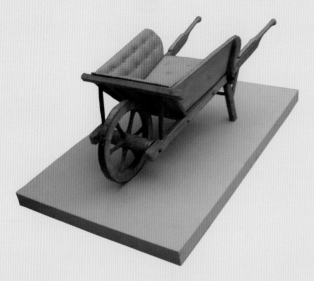

Opposite: Man Ray: Model in Dominguez' *Wheelbarrow*. Gelatin silver print. 1937. V&A: PH.240–1985

Left: Oscar Dominguez, *Brouette* (Wheelbarrow). Wood and padding of pink satin. Before 1937. Musée d'art moderne de la ville de Paris

the hall, changing its appearance into a nightmarish stalactite cave. Supposedly filled with coal (it was actually newspaper), they hung heavily just above the viewers' heads, effectively distracting attention from the paintings at the walls. Other distractions were the absence of gallery lighting, instead of which visitors were given torches, a strong scent of brewing Brazilian coffee, and the sound of hysterical laughter from a hidden phonograph.

Upon visiting the exhibition, Wassily Kandinsky joined a widespread criticism that Surrealism had lost its intensity by becoming fashionable:

The rush on the Vernissage was such that two large police cars had to come to keep the people away from the entrance because the galleries were so overcrowded that people were fainting. This might also have been due to the 'air' which had been perfumed and smelly. '*La plus haute volée de Paris*' arrived in scores in the most beautiful cars. All in evening dress. Some of the women's decolletées were such that the dress was scarcely visible ... Some (even old) ladies wore sandals with their nails being coloured blue, green, mauve. It seemed as if the audience had tried to outdo the artists – who could be more surreal.[16]

Indeed, the fact that Georges Wildenstein, the owner of the fashionable and usually very conservative Galerie Beaux-Arts, had offered his exhibition space, was a significant shift in recognition for Surrealism.

LEONOR FINI AND SURREALISM:
FANTASTIC FURNITURE

One year after the exhibition at the Galerie Beaux-Arts, Leonor Fini invited several of her artist friends, among them Meret Oppenheim and Max Ernst, to participate in the opening exhibition of a new gallery on Place Vendôme, Paris. The Galerie d'Art Décoratif was the joint venture of two young art entrepreneurs, René Drouin and Leo Castelli. Inspired by the success of Jean-Michel Frank and Pierre Chareau, Drouin and Castelli decided to join forces and open a gallery for luxury furniture. The scheme for the gallery, conceived during autumn 1938, was to commission artists to create fantastic furniture and objects which would then be sold through the gallery.

After months of preparation the official inauguration of the gallery was celebrated with a glamorous party on 5 July 1939. The impending outbreak of war was a common theme of the exhibits. Max Ernst had submitted *L'ange du foyer* (The Fireside Angel), painted in 1937, a strange bird-like animal in a menacing pose, the silhouette of which formed a swastika as a bleak commentary on Hitler's threat to Europe. A less direct reference to this theme appeared in Meret Oppenheim's *Table with Bird's Legs*: the uncanny absence of the protagonists – birds which had left their footprints on the table top – and the mutilated bird whose long legs remain, struck a far more unsettling note than the earlier fur cup and saucer.

Leonor Fini contributed a large cabinet on which she had painted two figures with wing-shaped legs,

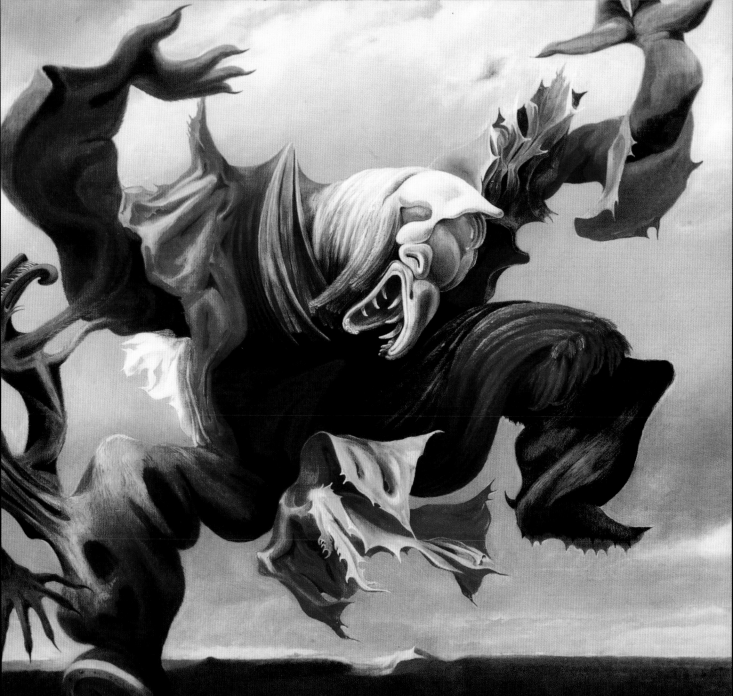

Leonor Fini and Surrealism: Fantastic Furniture

Previous page: Max Ernst, *L'ange du foyer* (The Fireside Angel), detail. Oil on canvas. 1937. Private collection

Left: Leonor Fini, *Armoire anthropomorphe* (Anthropomorphic Wardrobe). 1939. Private collection

Right: Eugène Berman, Wardrobe. Oil paint on canvas, varnished, on pine carcase. 1937. V&A: W.27–1987

Opposite: Meret Oppenheim, *Table with Bird's Legs*. Bronze and wood. 1939. Private collection

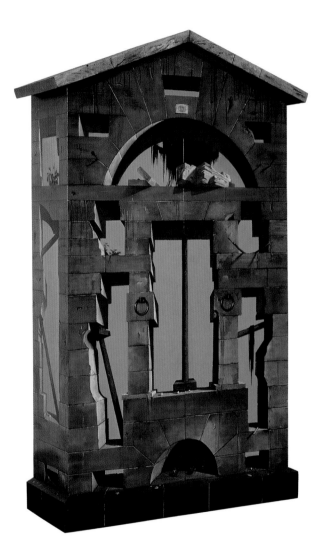

and Eugène Berman a large wardrobe which represented a ruined architectural structure. The architectural elements of the wardrobe appeared as the shell of a structure whose hemispherical arch resembled those of early Christian catacomb tombs. This allusion to decay and death added to the general melancholy of the piece, which evoked feelings of sinister monumentality through its size and the choice of dark, gloomy colours. The consistent deep blue of the background recalled a darkened nocturnal sky, in stark contrast to the sharp lines of shadow and light on the walls, another uncanny element which added to the disturbing timelessness of the object.

LEONORA CARRINGTON AND
MAX ERNST: HORSES AND BIRDS

In summer 1938, Max Ernst left Paris to escape the
increasing quarrels between the Surrealists, and to
live with Leonora Carrington, whom he had met the
previous year in London. What had been planned
as a summer sojourn in the village of St Martin
d'Ardèche lasted one and a half years, during which
both artists converted the country house they had
acquired into a mythic realm of beasts and chimeras.
Ernst covered the outer walls of the farmhouse with
cement relief sculpturesof hybrid creatures with
wings and beaks which greeted the approaching
visitor. One of these 'vigilant monsters' (as Roland
Penrose described them when visiting in summer 1939)
was an over-life-size horned mermaid of undefined
or androgynous gender. Its sexual inversion was
peculiar to most of the creatures around the house,

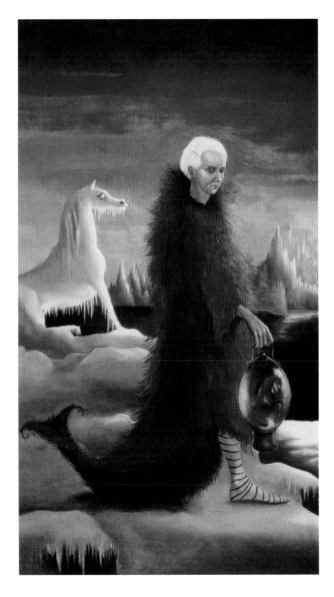

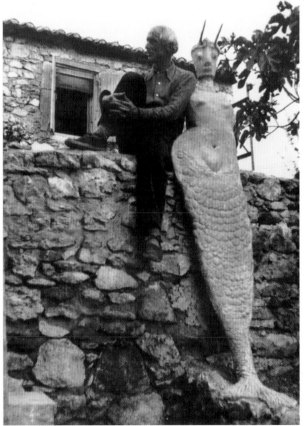

Opposite: Max Ernst, Sculptures in St Martin d'Ardèche. Photograph by Lee Miller. 1938. Lee Miller Archives

Left: Leonora Carrington, Portrait of Max Ernst. Oil on canvas. 1939. Private collection

Below: Max Ernst and the 'Horned Mermaid', St Martin d'Ardèche, 1938. Lee Miller Archives

Leonora Carrington and Max Ernst:
Horses and Birds

as it was to many figures in Leonora's stories written at the time.

The mermaid's fishtail reappeared in Carrington's portrait of Max Ernst, which shows him standing in an Arctic landscape holding a lantern which contains a small horse. A frozen horse in the background has been interpreted as an early expression of her suffering in a relationship with the much older and unpredictable Ernst. This was underlined in one of her biographically fuelled novels of the time, *Fly, Pigeon*, in which an elderly man, characterized by white skin, striped stockings and a feathered coat, tries to convince his young wife of his alleged youth. Despite these reservations about their relationship, Carrington later remembered the time at St Martin as an 'era of paradise'. Working together as well as individually in their respective studios, both artists

created a considerable body of work which strongly corresponded to the other's imagery and iconography.

When war broke out in September 1939, Max Ernst, despite having lost his German citizenship six years ago, was arrested and interned in a concentration camp in nearby Largentière. He was released before Christmas thanks to the intervention of Paul Éluard, and returned to St Martin where he embarked on several large paintings, including *La toilette de la mariée* (The Attirement of the

Bride), in which he resumed the collaborative dialogue with Leonora. Inspired by his experiments with decalcomania during the internment, he created a double picture in which a mirror at the back echoed the scene of the foreground. There a central female figure with an owl's head is accompanied by a bird-like creature pointing its spear towards her vagina, and a second nude. The brilliant red robe of the main figure alludes to Ernst's outfit in Leonora's portrait of the previous year, as does the human leg that is visible under the feathered coat of the beaked creature on the left, which echoes the striped leg in the portrait of Ernst.

The short-lived partnership of Carrington and Ernst ended with his second arrest, after which Carrington, suffering a mental breakdown, sold the house and escaped to Spain. During the chaos of the French defeat Ernst was able to escape and return to St Martin, only to find the house sold and Leonora gone. Having recovered some of his and Leonora's paintings, he travelled to Marseille where he hoped to obtain an exit visa to leave Europe. There he was reunited with several Surrealist friends at the Villa Air-Bel, rented by the American Emergency Rescue Committee to hide European intellectuals, artists, musicians and politicians in danger of being persecuted by the Nazi regime or its collaborators. During one of the long days spent waiting for his visa to arrive, Ernst mounted an impromptu exhibition of his and Leonora's paintings on a tree in front of the villa. It was to be the last Surrealist exhibition on European soil for a long time.

Opposite: Max Ernst, *La toilette de la mariée* (The Attirement of the Bride). Oil on canvas. 1940. Peggy Guggenheim Collection, Venice (Solomon R. Guggenheim Foundation, NY)

Below: Hans Bellmer, Portrait of Max Ernst in brick. Pencil and white gouache. 1940. Art Institute Chicago

Leonora Carrington and Max Ernst: Horses and Birds

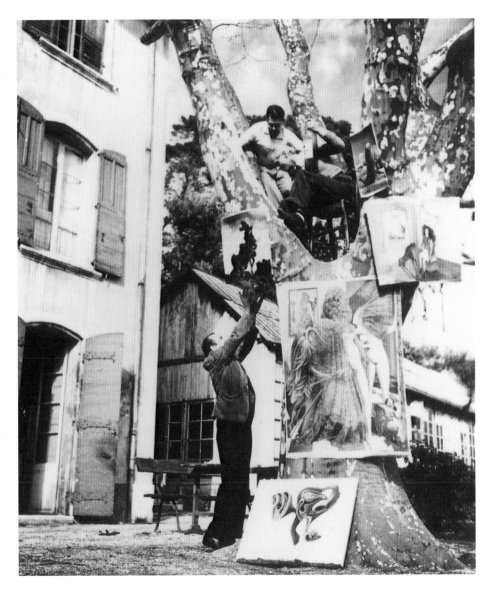

Opposite: Leonora Carrington, *Self portrait* (*Inn of the Dawn Horse*). Oil on canvas. 1937–8. Metropolitan Museum of Art, New York

Left: The 'Vernissage' at the Villa Air-Bel in Marseille, 1941: Jacques Hérold, Max Ernst and Daniel Bénédite hang paintings by Carrington and Ernst on a tree for an auction of artworks. Collection of Mme Daniel Ungemach-Bénédite

PEGGY GUGGENHEIM AND FREDERICK KIESLER: ART OF THIS CENTURY

Peggy Guggenheim's career as one of the most important collectors of Surrealist art began in January 1938 with the opening of her art gallery Guggenheim Jeune on Bond Street in London. Marcel Duchamp, with whom she had been acquainted since the early 1920s, had already taught her the fundamentals of contemporary art, and when her gallery proved to be a financial failure she decided to open a museum of modern art instead.

Her next advisor was Herbert Read, whom she met the following year. He drew up a list of the most important living artists, which became the basis of her collection. Her patronage led to her acquaintance with the Surrealist group and several stormy love affairs with members of the movement, including Yves Tanguy, Marcel Duchamp and, in 1941, Max Ernst, whom she helped to escape to the United States where the two married hurriedly.

For the first six months of 1940 she had been able to buy almost 'a painting per day' when artists and gallery owners tried to sell their stocks in order to be able to leave Paris before the German troops invaded. With the assistance of Marcel Duchamp, Howard Putzel and Nelly van Doesburg, Peggy Guggenheim managed to acquire more than seventy works from galleries, private collections and artists' studios. A descendant of a well-known Jewish family, Guggenheim showed considerable courage by remaining in Paris until the last moment, before heading south where she was able to hide her collection at the Musée de Grenoble. The collection itself made an odyssey through the unoccupied zone of France,

Left: Yves Tanguy, Earrings with miniature landscapes made for Peggy Guggenheim. Oil on celluloid. 1938. Private collection

Below left: Peggy Guggenheim wearing the Tanguy earrings. Peggy Guggenheim Collection, Venice (Solomon R. Guggenheim Foundation, NY)

Below: Yves Tanguy, *Le soleil dans son écrin* (The Sun in its Jewel Case). Oil on canvas. 1937. Peggy Guggenheim Collection, Venice (Solomon R. Guggenheim Foundation, NY)

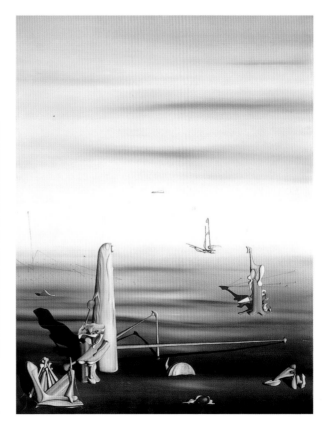

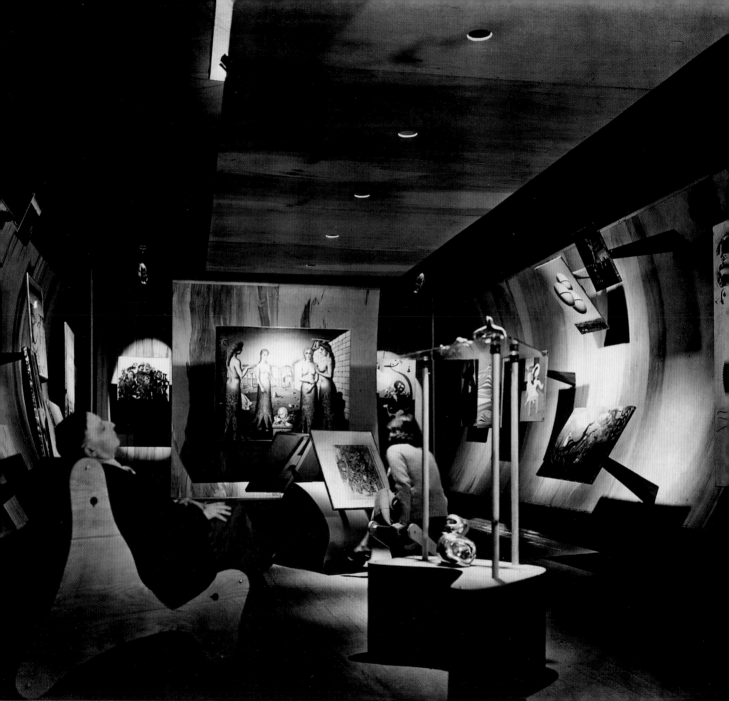

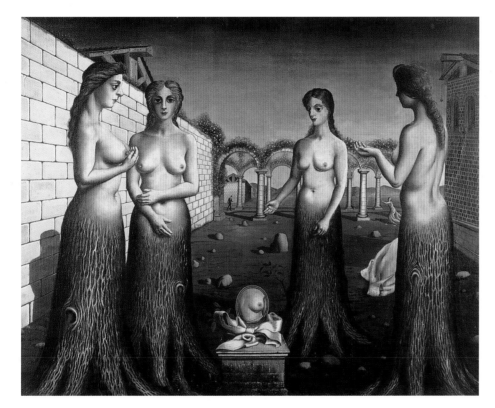

and finally arrived in New York where it was to have a huge impact on a rising generation of young American artists – as well as on the audience in New York, which had previously only associated Surrealism with Dalí's raucous appearances.

The Art of This Century Gallery was the result of a very productive collaboration between Peggy Guggenheim, Marcel Duchamp and Frederick Kiesler. Guggenheim had started to enquire about a suitable location for a gallery-museum in which to exhibit her collection soon after her arrival in New York. Either André Breton or Jimmy Ernst, Max's son, who at the time had become Peggy Guggenheim's secretary, recommended Frederick Kiesler as an architect who could create a dramatic interior for a contemporary art gallery. Frederick Kiesler had studied architecture in Vienna and emigrated to America as early as 1926, from which time he played an important role as an exhibition designer as well as a

Peggy Guggenheim and Frederick Kiesler: Art of This Century

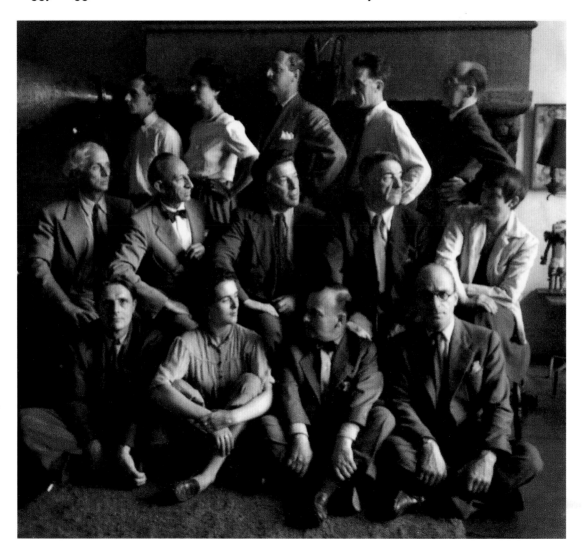

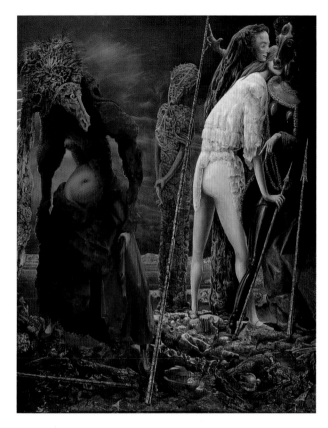

Surrealists' attempts to unite objects and surrounding space by building a sculptural shell and object-like furniture which blurred the boundaries between architecture, sculpture and painting.

Art of This Century opened on the night of 20 October 1942. As Jimmy Ernst remembered:

> The opening night crowd had been huge,
> the subsequent press coverage nationwide and
> favourable, catalogue sales were brisk
> and daily attendance was consistently large …
> Admittedly the real success of Art of This
> Century was its collection of paintings and
> sculpture and Kiesler's genius at transforming
> two dilapidated lofts into a magic environment
> of constant surprises.[17]

theorist and facilitator of avant-garde art projects and exhibitions. It was probably through Duchamp that Kiesler was introduced into the Surrealist circle.

In late April 1942, Kiesler submitted a detailed 'outline specification' which described the principal elements of the design: for the 'Surrealist Gallery' he envisaged curved walls, projecting arms, a hanging ceiling and his multi-use 'Correalist furniture'. Kiesler continued the

THE DISBANDMENT OF SURREALISM

It remains a matter of debate as to when Surrealism came to an end. Some suggest the movement disbanded with the occupation of France and the dissolution of the Paris group in 1940, others that Surrealism is very much alive and well today. It can be argued that it was extinguished with André Breton's death on 28 September 1966, although recent scholarship has extended the boundary to 1968, focusing on the movement's political impact and later generation of adherents. Indeed, the new generation of poets and artists who joined the movement after the war revived the political engagement of its early days.

But clearly much of the energy and revolutionary fervour of its protagonists had been lost after the war. André Breton, who hoped to revive the movement after his return to France in 1946, found himself deprived of his usual circle of friends, who were scattered around the world. Paris, physically unharmed by the war, had suffered an invisible but profound loss during the occupation. Its position as the stage of the world's avant-garde had been erased with the exodus of French and foreign intellectuals, artists, poets, musicians, gallery owners and publishers. For the Surrealists, Paris had not only been a stage, but also the geographical centre of its activities. The collaboration that had been facilitated through shared studios, the daily gatherings at Place Blanche and joint exhibitions was rendered impossible with the departure from the French capital and the lack of a similarly fertile cultural environment in New York.

Max Ernst summed up the collective disappointment in his 1945 interview with James Johnson Sweeney: 'During my first months in New York there were many Paris painters

here. At first the Surrealist groups seemed to have a real strength; but little by little they began to break up. It was hard to see one another in New York. The café life was lacking. In Paris at six o'clock any evening you knew on what café terrace you could find Giacometti or Éluard. Here you have to 'phone and make an appointment in advance. And the pleasure of a meeting had worn off before it took place.'[18] The lack of 'fortuitous encounters' forced the artists who had formed this close-knit circle of friends to pursue their individual goals alone. Consequently their imagery was increasingly formed by personal style rather than by shared experiments. The influence of Surrealism on several generations of emerging young artists, however, was to be far-reaching: Abstract Expressionism, Informel, Art Brut, Arte Povera, Fluxus, Performance Art, and even Existentialism were all based on ideas and techniques explored in Surrealism. Its culture of discussion and collaboration, its theory and intellectual foundations, and not least its iconography, have shaped the artistic, social and political scene of the second half of the twentieth century and continue to haunt our unconscious to the present day.

Notes

1 Sweeney (1946), p.17

2 Breton (1924), pp.25–6

3 Ibid.

4 Man Ray (1963), p.58

5 Ibid., p.91

6 Philippe Soupault, *Profils Perdus* (Paris, 1963), p.166

7 Breton (1928), p.36

8 Russell (1967), p.87

9 Letter from Max Ernst to Camille Goemans, 2 June 1926, Archive of the Musée de la Littérature, Brussels

10 Salvador Dalí, 'Objets Surréalistes', *Le Surréalisme au Service de la Revolution* (Dec 1931), no.3, p.17

11 Reuterswärd (1967)

12 Nash (1936), pp.151–4

13 Agar (1988), p.115

14 Ibid., p.117

15 Ibid., p.168

16 Letter from Wassily Kandinsky to Otto Nebel, Neuilly sur Seine, 11 February 1938, published in *Berner Kunstmitteilungen* (Bern, Jan/Feb 1981), no.203, p.13

17 Ernst (1992), p.234

18 Sweeney (1946), p.17

Picture Credits

Further Reading

Aberth, Susan, Leonora Carrington: *Surrealism, Alchemy and Art* (Aldershot and Burlington, 2004)

Ades, Dawn, *Dalí: the Centenary Retrospective* (London, 2004)

Agar, Eileen, *A Look At My Life* (London, 1988)

Angliviel de La Beaumelle, Agnes (ed.), *Joan Miró, 1917–1934: La Naissance du Monde* (Paris, 2004)

Bonnefoy, Yves, *Alberto Giacometti: Biographie d'un œuvre* (Paris, 1991)

Breton, André, *Manifestes du Surréalisme* (Paris, 1924, trans. Richard Seaver and Helen R. Lane, Ann Arbor 1969)

Breton, André, *Le Surréalisme et la Peinture* (Paris, 1928, trans. Simon Watson Taylor, Boston, 2002)

Breton, André, *Le Surréalisme au Service de la Revolution* (Paris, 1931)

Caws, Mary Ann (ed.), *Surrealism* (London, 2004)

Caws, Mary Ann, Kuenzli, R.E. and Raaberg, G. (eds), *Surrealism and Women* (Cambridge, Mass., 1991)

Chadwick, Whitney, *Women Artists and the Surrealist Movement* (London, 1985)

Curiger, Bice (ed.), *Meret Oppenheim: Spuren durchstandener Freiheit* (Zürich, 1982)

Di Crescenzo, Casimiro, *Alberto Giacometti: Early Works in Paris 1922–1930* (New York, 1994)

Durozoi, Gérard, *History of the Surrealist Movement* (London, 2002, first published as *Histoire du Mouvement Surréaliste*, trans. by Alison Anderson, Paris, 1997)

Ernst, Jimmy, *A Not-So-Still Life* (New York, 1992)

Flanner, Janet, *Paris Was Yesterday, 1925–1939* (London, c.1973)

Golan, Romy, *Modernity and Nostalgia: French Art and Politics Between the Wars* (London, 1995)

Guggenheim, Peggy, *Out of This Century: Confessions of an Art Addict* (London, 1979)

James, Edward, *The Gardener Who Saw God* (London, 1937)

Jean, Marcel, *The History of Surrealist Painting* (London, 1960)

Kachur, Lewis, *Displaying the Marvelous. Marcel Duchamp, Salvador Dalí, and Surrealist Exhibition Installations* (Cambridge, Mass., 2001)

Levy, Julien, *Surrealism* (New York, exh. cat., 1936)

Levy, Julien, *Memoir of an Art Gallery* (New York, 1977)

Lottmann, Herbert R., *Man Ray's Montparnasse* (New York, 2001)

Mahon, Alyce, *Surrealism and the Politic of Eros,* 1938–1968 (London, 2005)

Man Ray, *Self Portrait* (London, 1963)

Meyer-Thoss, Christine, *Meret Oppenheim: Book of Ideas* (Bern, 1996)

Mundy, Jennifer (ed.), *Surrealism. Desire Unbound* (London, exh. cat., 2001)

Nadeau, Maurice, *History of Surrealism* (London, 1968)

Nash, Paul, 'Swanage or Seaside Surrealism', *Architectural Review* (April 1936)

Penrose, Antony, *The Lives of Lee Miller* (London, 1985)

Penrose, Roland, *Miró* (London, 1970)

Powers, Edward D., 'Meret Oppenheim – or, These Boots Ain't Made for Walking', *Art History* (June 2001), vol.24, no.3, pp.358–78

Read, Herbert, *Arp* (London, 1968)

Read, Herbert Edward (ed.), *Surrealism* (London, exh. cat., 1936)

Reuterswärd,Carl Fredrik, 'Le Cas Oppenheim', *Meret Oppenheim* (Stockholm, 1967), n.p.

Russell, John, *Max Ernst, Life and Work* (London, 1967)

Schwarz, Arturo (ed.), *I Surrealisti*, (Milan, exh. cat., 1989)

Schwarz, Arturo, *The Complete Work of Marcel Duchamp* (London, 1997)

Schwarz, Arturo, *Man Ray: The Rigour of Imagination* (London, 1977)

Segalat, R. J., *Album Eluard, Iconographie reunie et commentee* (Paris, 1968)

Spies, Werner (ed.), *La Revolution Surréaliste* (Paris, exh. cat., 2002)

Spies, Werner (ed.), *Max Ernst: A Retrospective* (New York, 2005)

Sweeney, James Johnson, 'Eleven Europeans in America', *The Museum of Modern Art Bulletin* (1946), vol.xiii, nos 4–5

Tanning, Dorothea, *Birthday* (Santa Monica, 1986)

Tanning, Dorothea, *Between Lives, An Artist and Her World* (Evanston, 2001)

Vail, Karole P.B. et al., *Peggy Guggenheim. A Celebration* (New York, exh. cat., 1998)

Waldberg, Patrick, *Les demeures d'hypnos* (Paris, 1976)

Index